KENTUCKY
BOOK OF THE DEAD

KENTUCKY
BOOK OF THE DEAD

Keven McQueen.
Apr. 5, 2024

KEVEN MCQUEEN
ILLUSTRATIONS BY KYLE MCQUEEN

THE
History
PRESS

Published by The History Press
Charleston, SC 29403
www.historypress.net

Copyright © 2008 by Keven McQueen
All rights reserved

All illustrations by Kyle McQueen

First published 2008
Second printing 2011
Third printing 2012

Manufactured in the United States

ISBN 978.1.59629.524.7

Library of Congress Cataloging-in-Publication Data

McQueen, Keven.
Kentucky book of the dead / Keven McQueen ; illustrations by Kyle McQueen.
p. cm.
Includes bibliographical references.
ISBN 978-1-59629-524-7
1. Ghosts--Kentucky. 2. Death--Kentucky--Miscellanea. I. Title.
BF1472.U6M44 2008
133.109769--dc22
2008021047

Dedicated to my grandparents:
Walker and Lellie McQueen and Jess and Della Casteel.

It's obvious that we don't know one millionth
of one percent about anything.

—*Thomas Edison*

CONTENTS

A NOTE TO THE GENTLE AND PATIENT READER

There is neither rhyme nor reason to the organization of this book. It is not arranged chronologically and barely by topic. It is intended simply to be a mélange of bizarre incidents and entertaining, sometimes macabre factoids and incidents from Kentucky's past, interspersed with droll commentary—sometimes half-believing and sometimes skeptical. The subjects broached include ghosts, strange deaths, old-time embalming procedures and the paranormal.

I cannot vouch for the accuracy of the stories in this book. Most came from long-lost accounts in newspapers from the nineteenth and early twentieth centuries. When uncovering an amazing story I had to speculate: was the account true as stated? Or did it result from poor reporting? Was it an outright hoax? Journalists at the time were notorious for reporting some wonder and then running no follow-up stories, resulting in frustration and bleeding ulcers for modern researchers who want more details. Additionally, newspapermen saw nothing wrong with concocting soberly written hoaxes to entertain their readers. I tried to verify each story through the magic of backbreaking research, but all too often it proved impossible due to the inadequate preservation of small-town Kentucky newspapers. On rare occasions when I found conflicting accounts or proof of a hoax, I made sure to mention so.

In other words, feel free to believe as much of the following as you like; if you pick up any nuggets of legitimate history, it will be by accident and not by design.

THEY WERE MY OWN RIGHT HAND

Rob Aken of the University of Kentucky Library, Berea College Archives and Special Collections, Geneta Chumley, Drema Colangelo, Rose Coleman, Jackie Couture, Paula Cunningham, Sarah Davenport, Eastern Kentucky University Archives and Special Collections, Eastern Kentucky University Departments of English and Theatre, Eastern Kentucky University Interlibrary Loan Department, Lee Feathers, Dr. Jim Gifford, Tammy Horn, Mr. and Mrs. Jones, Rene McGuire, Kyle and Bonnie McQueen, the Darrell McQueen family, Charles and Lashé Mullins, Pat New, Colleen O'Connor Olson, Deonna Pinson, Joy Sawyers, Gaile Sheppard, Michelle Steele, Kathy Switzer, Mia Temple, University of Kentucky Interlibrary Loan Department, the staff at White Hall State Historic Site, John Wilkinson and the staff at The History Press and Shannon Wilson. And of course, the Man Upstairs, as He is colloquially known.

Musical inspirations include Ben Eshbach, Kiara Geller, Joe King and Colonel J.D. Wilkes.

This book was edited by Lee Feathers.

Check out KevenMcQueen.com! Friend me on Facebook!

THE GHOSTS OF WHITE HALL

Cassius Marcellus Clay (1810–1903) may be one of the most underrated characters in Kentucky's, if not the nation's, history. Despite being the son of Madison County's Green Clay, one of the largest slaveholders in the state, Cassius was one of the most vocal emancipationists in the South. He was handsome, willful, tall, powerfully built and usually armed. The last two traits served him in good stead, as he was involved in innumerable fistfights and duels in his lifetime.

A brief listing of his more famous fights may provide an insight into Clay's times. In May 1841, he fought an inconclusive duel with his political enemy, Robert Wickliffe Jr.; unsatisfied, Wickliffe hired a professional thug named Sam Brown to kill Clay. On August 1, 1843, Brown attended a political rally at Russell Cave, Fayette County, with the intention of picking a fight with Clay and shooting him during the trouble that would follow. Brown's plan worked well except for a few minor details. The bullet he fired ricocheted harmlessly off a scabbard Clay kept concealed in his waistcoat. The scabbard happened to contain Clay's favorite weapon—a bowie knife—and within moments, Sam Brown parted company with his ear, nose and eye. To save Brown's life, if not his dignity, his friends rushed the stage and tossed him over a fence and into a spring. Brown survived, even if his looks did not.

A couple of years later, a mob broke into the Lexington office where Clay published his antislavery newspaper, the *True American*, and made off with his printing press. It is worth noting that they waited until Clay was bedfast with typhoid fever before attempting such a move. Clay's most serious fight came on June 15, 1849, when he insisted on making an antislavery speech at a proslavery rally at Foxtown, Madison County. A riot ensued, during which an enemy stabbed Clay in the side with his own knife. When he regained control of the weapon, Clay sank it into the abdomen of another attacker, Squire Turner. Turner died thirty-two hours later and Clay required several months to recover.

In addition to these adventures, Clay was also an early co-founder of the Republican Party. His campaigning on behalf of Abraham

Lincoln in 1860 resulted in the president naming Clay the minister plenipotentiary to Russia, where he served from 1861 to 1869. He got along well with Czar Alexander II and was instrumental in preventing Russia from siding with the Confederacy during the Civil War. Clay always maintained that he, not Secretary of State William Seward, should have been given credit for persuading the czar to sell Alaska to the United States.

Something now must be said of Clay's remarkable house in Madison County, located eleven miles north of Richmond. The original house was built in 1798 by Clay's father, who called it Clermont. While Cassius was in Russia, his wife, Mary Jane Warfield Clay, supervised an architectural expansion of the house. As a result, Clermont went from two stories to three and from eight rooms to forty-four, including the walk-in closets. It was one of the first houses in America to feature central heating and indoor plumbing, which consisted of a flushing commode, a sink and a bathtub—each in its own separate, adjoining room. At some indeterminate point, the house became known as White Hall rather than Clermont.

When Clay returned home from Russia in 1870, he found that his marital relations were irreparably strained—the fact that he adopted a Russian boy of uncertain parentage undoubtedly had something to do with it—and his wife left the palatial house in 1871. She moved to Lexington, never to return on a permanent basis. The couple officially divorced in 1878.

Clay also found that after his pet cause, the ending of slavery, had been accomplished, he was a *persona non grata* in politics. For the rest of his life, he made sporadic attempts to reenter the political arena, never with his previous success. He grew old and eccentric in his enormous, empty house with little company other than his servants, some of whom were afraid of him. He whiled away some time writing his memoirs, which were published in 1886.

The eighty-four-year-old Clay made national headlines in November 1894 when he married a fifteen-year-old tenant farmer's sister named Dora Richardson. A group of men, convinced the girl was being held against her will, came to "rescue" her. They slunk away after Clay threatened to fire a cannon full of shrapnel

at them. (He did not actually do so, local legend to the contrary.) But whatever happiness Clay attained with his "child bride," as the press called her, was fleeting. They divorced in September 1898, but remained cordial.

Clay's remaining years were marked by loneliness and increasing senile dementia. Legend maintains that he recaptured something of his former glory when he killed two burglars in self-defense and chased away a third, circa December 1899, at the age of eighty-nine. By July 1903, he was on his deathbed in his house's library. The bedridden old gladiator impressed onlookers one day by grabbing a rifle and blowing to atoms an annoying housefly that had lit on the ceiling. Poetically, he died during a violent thunderstorm on the night of July 22.

After Clay's death, his already-decrepit house was leased by his descendants to several generations of tenant farming families. By 1965, White Hall was abandoned and had become prey for vandals. In 1968, two of Clay's great-grandchildren—Warfield Bennett Jr. and Esther Bennett—gave the mansion to the Commonwealth of Kentucky. A thorough restoration project ensued, spearheaded largely by Beula Nunn, wife of Governor Louie B. Nunn. The house was opened to the public in 1971 and has since received many original pieces of Clay family furniture for display.

White Hall is the delight of history buffs and lovers of antiques, but there is a third reason the place is popular with tourists: it has had the reputation for years of being one of the most haunted houses in Kentucky. Many tour guides, employees and visitors claim to have witnessed things of a paranormal nature. In my book, *Cassius M. Clay, Freedom's Champion*, I recounted several ghost stories about White Hall. Here I will summarize some of those stories, as well as include events that have occurred in the house since the publication of the book in 2001.

Strange lights have long been a notable sight at White Hall. A woman whose tenant farming father had been born in the house in 1911 told me that when he was growing up on the grounds, residents saw a mysterious light bobbing around on the vast yard at night as though someone were carrying a lantern. Reports of

eerie doings at White Hall date to the late 1960s, when the state was restoring the house. Guards reported seeing candlelight moving from window to window in the second-floor master bedroom. (Since then, others, including a park manager and two rangers, have seen lights moving around in the windows of this room and the adjoining tower room; the cousin of the present curator saw the silhouette of a human looking out one of the master-bedroom windows as he was plowing a field next to the house. He reported seeing a light come on behind the figure and assumed it was a light with an automatic timer. But there were no automatic timers in the mansion and nobody inside, as it was past closing time.) Probably the most frequently told tale from what we might call the restoration era involves a watchman who happened to be a descendant of Cassius Clay's son Brutus. One memorable night, he turned out the lights in the house, locked up and headed for his car, only to look over his shoulder and see a lamp still on in Brutus's bedroom. The guard entered the building and took the long, lonely walk to the third floor in order to turn the lamp out again. After doing so, he again locked up and left the building, but when he was about to leave the grounds he noticed that the light was on again. Depending on which account is accurate, either he stomped into the house for the third time and ordered the ghost to knock off the horseplay— which it did—or his nerves compelled him to leave immediately.

Spirits rarely are sighted at White Hall, but they make their presence known through a variety of creative sounds and smells. In the latter category are the odors of pipe smoke and perfume, which a tour guide described as smelling "very old-fashioned." The smells often are concentrated in one or two central locations; they do not spread through the house's atmosphere, as scents naturally do, and are wont to disappear at a second's notice. Other witnesses have smelled brandy. Around Halloween every year, the Kentucky State Parks system and the Theatre Department at Eastern Kentucky University cosponsor the Ghost Walk play held in the house. In October 1994, Lashé, then an actress in the Ghost Walk, smelled burning candle wax as she passed through the dining room. There were no actual burning candles, as they are strictly forbidden in the house.

Guides, staff and tourists have heard footsteps in sections of the house that proved empty upon inspection. Lucy, a Madison County resident who was White Hall's housekeeper for over twenty years, often heard heavy footsteps that sounded as if they were made by a large male in flat shoes and lighter steps that made her think of a woman in high heels. Another employee who heard the footsteps was Lee C. One day in July 1992, she twice heard someone walking down the back steps leading into the basement. Later, she found that she had been alone in the basement; all other employees had been in the gift shop at the time she heard the steps. Seven months later, a former guide named Kathy was in the powder room (the room under the mansion's circular stairs) when she and another guide heard someone walking down the stairs. They emerged from the room immediately, but found no one in the house.

The footsteps resurfaced in December 2000, when curator Lashé and her husband Charles dropped by the house after business hours. Lashé was taking pictures of the house's Victorian-era Christmas decorations as Charles went to the business office to copy some holiday tour programs. As Lashé took the photos, she suddenly heard the sound of someone walking on the second floor:

> *I did not think anything of this at first. The mansion does not have a great deal of overhead lighting and so we have to turn on table lamps to provide supplemental light in the evening. I assumed that this was what Charles was doing. It took me a few minutes to realize that Charles was not in the house with me, but was actually still up in the office making program copies. The business office is connected to the backside of the mansion, but in order to get into it one has to go outside of the main house and go up a steep stairway. Although it is a part of the mansion, one cannot access the business office directly from the main house. I went outside to the office to confirm this and, sure enough, Charles had been in the office the whole time. I know for a fact that no one else was in the mansion with me because Charles and I were the only people on the park and we had unlocked the mansion to get into it.*

On occasion, people have heard violin or piano music echoing in the empty ballroom (also known as the drawing room). Some lucky persons have even heard the sounds of a party along with the music. One night, the former housekeeper, Lucy, spent the night in an upper-floor bedroom with four other women just to see if anything would happen in the house. Around 2:00 a.m., all of the women were awakened by the sound of a lonely violin playing downstairs. The music abruptly ceased when the women trooped downstairs to investigate. In November 1992, Lee C. heard a violin playing as she painted a wall in the house's warming kitchen. She listened for an hour and a half, assuming it came from the secretary's radio. The music stopped when Lee invited Kathy the guide into the kitchen to hear it. Lee later found that the secretary's radio had been off the whole time. In summer 1999, tour guide Rose heard faint fiddle music while sitting in a chair in the master bedroom. She wrote: "The air conditioner wasn't running at the time so it wasn't the culprit and I only heard it that one day, never again, even though I tried to hear it again many times."

Other White Hall employees, including myself, have heard cacophonous sounds issuing from the cavernous basement or from an upstairs room (usually the tower room). The noise sometimes sounds like someone banging together pieces of metal and sometimes like heavy furniture being dragged. Inevitably, when a search is made, the rooms from which the noises issued are in perfect condition. In 1998, a guide named Michelle was standing in the powder room when she heard a sound "like a table being scooted or a wooden chair being dragged across the floor" coming from the tower room overhead. A quick search revealed nothing out of place. Lashé M. recalls hearing the same sound coming from the tower room while she sat on the front porch one day. A guide named Cindy was present and also heard it. The noise continued sporadically until Lashé left the front door open. Then it stopped.

In the 1980s, White Hall had a phone intercom system that permitted persons to eavesdrop on any room that contained a phone. This proved to be not as much fun as it might sound. On one occasion when the house was closed, Lucy the housekeeper pressed on an intercom button while at her house on the grounds.

She heard the sound of people walking in the powder room. In another instance, also after business hours, Lucy listened in on the powder room intercom and heard paper shuffling. She and her husband Bill immediately investigated and found the house empty. And one day in August 1991, Lee C. pressed the powder room's intercom button and heard a party going on: "I could hear music, the sound of people dancing and what seemed like dozens of voices talking all at once." She hung up the phone in awe. A few seconds later, she turned the intercom on again. This time, the room was silent as the tomb.

On some memorable occasions, employees have heard disembodied voices. Former guide Kathy S. claims to have heard a man's voice clearly say "Katherine" twice just outside the master bedroom one summer morning in 1990: "I ran through the second-floor hallway, down the main staircase and into the powder room. I slammed the door and did not come out until the

housekeeper and maintenance man arrived…I can't say it was hateful by any means when it called me. It was one of the most frightening experiences I've ever had." Kathy also recalls hearing voices when giving a tour:

In July or August 1992, I was on the third floor with my group, showing them the history room. We were talking about the artifacts when I heard voices. They were muffled and yet very loud. They sounded like they were coming from between the walls of the blue room and the history room. They were men's voices—several people—and they seemed to be arguing. The guests also heard it. On my next tour, I heard the voices again and in exactly the same spot. Again, the guests heard it. We all stood there looking at each other. One woman was extremely frightened and said she had to leave the floor. So, we quickly retreated down the stairs to the first floor. I've also heard faint voices in the library and the ballroom. We also heard voices in the basement one time. You can't make out what they're saying, but you can distinguish men's voices from women's voices.

I remember an occasion in summer 1999 when I was preparing to show the third floor to a group from an elderhostel. Spooks and spirits were the last thing on my mind; in fact, I clearly recall that I was trying to remember the lyrics to the Rolling Stones song "Tumbling Dice." As I waited on a landing between the second and third floors (some sections of the house are built on split levels), I heard the muffled voice of a woman coming from the third-floor history room containing miscellaneous artifacts related to Cassius M. Clay and his family. I thought Amy, another guide, was pointing out some items of interest to a group. After a few minutes of silence, I thought I should warn her that the elderhostel members would be coming upstairs soon. When I went into the history room, no one was there. Later I discovered that Amy had taken her group downstairs long before I had shown up on the scene mentally untangling the lyrics to "Tumbling Dice."

Former guide Joy Sawyers recalls the occasion when she came to work early and, upon entering White Hall, heard the sound of

women laughing in the upstairs hall in front of Laura's and Sarah's rooms. She thought it was the park manager and the curator, but later she found out that they had been in their office, located over the house's back porch. In fact, at that moment, Joy had been the only (living) person in the mansion.

One summer morning circa 1998, Michelle, a guide, arrived at White Hall very early and underwent her usual routine. On the way to the third floor to change into her costume, she made a shortcut through Sarah Clay's second-floor bedroom. There are two closets in the room. Michelle noticed that the door on the closet on the right was almost completely closed and voices issued from within: "I heard a man and a woman arguing. They were whispering, but they were definitely arguing. They were unmistakably male and female voices. I assumed that [fellow engaged tour guides] Charles and Lashé must have shown up when I was in the basement and they were obviously having an argument that they wanted to finish before work, so I didn't yell at them to say hello or anything." A few minutes later, after changing, according to Michelle,

> I walked into the main hallway to unlock the front door and when I looked out the window, Charles and Lashé came driving up…I stepped out on the porch and asked them if they just got there—and they had. Lashé asked me why and I told her that I heard people arguing in Sarah's room and I thought it was them and she said no it wasn't, that they had just arrived. The door in Sarah's room was still cracked when I went up to check on it after they arrived. I needed to satisfy my own curiosity, needless to say.

Michelle had another strange experience on October 19, 1997, Cassius Clay's birthday. On this day, there were only two guides in the house. When Michelle finished a late afternoon tour on the back porch, she reached for the dining room door in order to reenter the mansion. The knob turned by itself before she touched it and the door opened. Michelle thought the other guide—who happened to be me—had heard her finishing her tour and had opened the door to be courteous. When she went to the powder room she found that

I had been sitting there reading for the past half hour and had not opened the dining room door for her.

Now we come to actual sightings of apparitions at White Hall. At least three ghosts have been seen. One is a dark-haired woman, usually wearing a dark dress, whom most assume is Clay's wife Mary Jane. Another is a young boy, possibly Clay's son Elisha; a guide at White Hall in the mid-1970s reported that when she glanced into the dining room one day, she saw the figure of a young boy with his back to her, warming his hands before the fireplace (in which no fire was set). The third is the imposing, well-dressed figure of Clay himself.

According to an article by Carolyn Siegel in the *Richmond Register* of October 25, 1989, in the summer of that year an entire tour group saw the ghost of a woman with dark hair and a black dress: "The guide and her visitors watched in stunned silence as the woman walked across the hall in front of the water closets, into [Sarah Clay's room], 'through' the guide rope, and into the closet." A similar event occurred on a stormy day, also in summer 1989. Joy Sawyers was giving the last tour of the day to an elderly couple. Joy went up the circular stairs ahead of the couple and waited in the hallway at the top of the stairs for them. As she waited, she glanced over to the right and saw a shadow on the floor of the water closet area. The person casting the shadow was hidden from sight, but as it appeared to be wearing a hoop skirt, Joy assumed it was Wilma, the other guide in the house that day. Joy was slightly annoyed, thinking that Wilma was listening in on her tour.

Joy showed the elderly couple the bedroom named for the Clays' suffragist daughter, Laura. Afterward, they went to Sarah Clay's room. As she spoke to the couple, she noted that the male tourist's eyes were moving as if watching something behind her. Turning, Joy saw a lady in a hoop skirt walking into the room. She went through the guide rope and into the right closet. (This is the same closet from which issued male and female arguing voices in the presence of Michelle several years later.)

"Did you see that?" asked Joy.

"Sure did," said the man. "She must be another guide." Evidently, he did not notice that the "guide" walked through the

rope and Joy did not bring the matter up. Excusing herself, she looked into the closet into which the woman had stepped, only to find it empty. Joy didn't tell the couple that they had just seen a ghost. "Somewhere, there may be two people who saw a ghost and didn't know it," she remarks today. Joy saw the woman's face only in profile, but she didn't observe the features so much as the hair, which she describes as being dark brown and pinned up in the back, but in long curls or ringlets on the sides. The hoop skirt and blouse were dark, though not black, and the woman's skirt had a bustle in the back. Bustles were not a feature of the female guides' costumes.

In 1994, Charles M. was showing the water closet and bathtub to a couple of tourists. As he spoke, Charles stood on the top step of a split-level stairway that leads to the master bedroom: "From my vantage point, I could only see this woman from the upper portion of her chest down to the floor and much of her form was obscured by the railing. However, I could see that she was wearing a white shirt and a blue hoop skirt very similar to the costumes worn by our female guides." Charles hurried upstairs and found only Jeffrey, another guide, and his tourists. No one else had noticed anything unusual and Jeffrey confirmed that no woman on his tour had been wearing a white shirt and blue dress. An inventory of costumes revealed that there were no blue hoop skirts in the house at the time.

A six-foot male figure has twice been seen in the basement, standing in the doorway to what used to be the tour guides' break room. In roughly the same area, Lashé caught a fleeting glimpse of a figure in nineteenth-century-style clothing in May 1999. She thought it was her fiancé Charles, who turned out to be elsewhere in the house.

One might expect the spirits to go into hiding during the annual Ghost Walk, when hundreds of audience members walk through the house. However, the actors and actresses regularly report strange goings-on and on at least one occasion a tourist may have seen something spectral. In October 2001, Mia Temple attended the Ghost Walk with her family. She wrote:

As we were being ushered around that maze of rooms on the second floor, I saw somebody moving out of the corner of my eye and turned to catch just a glimpse of someone's filmy [yellow] gown and one black shoe as they darted off beyond a doorway. I said to my sister, "Look, one of the guides wasn't fast enough!" because some of them were playing parts in two different areas; they were running around behind the scenes, down those concealed corridors and tiny stairways.

After making inquiries, Mia found that none of the actresses wore a yellow gown that night and that the room she saw the figure entering was Sarah Clay's, one of the house's supernatural hot spots. Mia had mixed feelings about her sighting: she felt both skepticism and belief, tempered by a sense of the creepiness of it all. "I hope it was a ghost, but I do wish I'd realized this when it was taking place—I'd have broken line and gone after her, by gosh! She wasn't scary at all—obviously, she wasn't see-through, I thought it was a normal, flesh-and-blood person. But it does give me a weird feeling to think about it."

The ghosts of White Hall show little sign of retiring. Often, months or years will pass quietly, and then a new rash of phenomena suddenly erupts. Curator Lashé now has guides and employees write down their experiences shortly after they happen. Following are some of the reports from recent years.

Charles M. heard a strange noise while giving a tour to two women on July 24, 2000. Some might dismiss it as an auditory hallucination, but the tourists also heard it:

Nearing the end of the tour, the ladies and I were descending from the third-floor hallway down the back staircase when we heard music. I was somewhat taken aback upon hearing the music as I instantly knew that I wasn't sure where the sounds were coming from. Knowing the layout of the house like the back of my hand, I knew the nearest and only radio in the mansion was located in the archives room nearby; however, I would discover [later] that it was not only turned off, but unplugged from the electrical outlet. After only a few seconds, the eldest lady on my tour asked,

"Is that a music box I hear?" It suddenly dawned on me that it did indeed sound like a music box and I responded, "Yes, it certainly sounds like a music box, however I can assure you there is none in this house."

The music stopped by the time the trio reached the bottom of the stairs. After the tour, Charles searched the house for the source of the music but found none. There are a couple of intriguing things to consider about this incident. For one thing, as Charles writes, "It is interesting to note that this paranormal activity occurred two days after the anniversary of Cassius M. Clay's death, a time of the year when strange and sometimes unexplainable things are thought to happen at White Hall." For another, Dora Richardson, Clay's teenaged second wife, is known to have owned a music box. For some reason, Clay forbade her to play it. Perhaps Dora's ghost is displaying a little postmortem defiance.

David, the husband of White Hall's park manager, was trying out his new digital camera in the house on June 19, 2002. His first problem came in the drawing room/ballroom: "I tried several times to photograph the painting of Cassius…but there was always something wrong with the picture. While every other picture came out fine, I could never get a good picture of Cassius." Everything went fine after that until he tried to photograph Clay's sword on display on the third floor:

I suddenly was overtaken by a feeling that I was no longer welcome. I had the clear and distinct feeling that someone was angry and wanted me to leave…and leave immediately! The anxiety grew until I had no option but to leave the room. Once I started down the stairs, and while still in view of the third floor, the feeling subsided and never returned. I have made several subsequent trips to the third floor and the feeling never returned…but I also never took my camera back to the third floor.

In 2003, tour guide Doris was dusting a cradle in the children's room in the Clermont section of the mansion. Suddenly, she heard a baby laughing: "I looked around surprised and the lamp

in the room went off and for about two weeks we couldn't keep the light on."

Tour guide Ben was opening the house one morning in May 2004. As he passed the dining room, he saw something. In his own words, "It was the silhouette of a person, not a shadow, but a silhouette clearly having a head and two arms. It was flat, not three dimensional, and was as black as the abyss. I continued past the dining room and stopped to go back and look again, but it was gone."

On June 29, 2004, tour guide Nikki had this experience:

> *Once while giving a tour in the drawing room of the home, I saw someone walking up to one of the doors I was standing by. I assumed it was another tour guide telling me I had more people on my tour. However, when I turned to look at the door, I saw a woman turn and walk away. I noticed the woman had an orangey-red skirt on. After I was done with my tour, I returned to ask what the other guide* [Buffy] *wanted. She replied that she never came to the door and then I noticed she had a dark blue skirt on. I decided to look at the dates to see if anything important had happened on that day regarding the family. Turns out* [Cassius Clay's daughter] *Laura Clay died that same day, June 29.*

On the morning of July 16, 2004, tour guide Buffy was alone in the house changing into her costume. The other two guides, Ben and Kirin, were outside. As Buffy came down the back staircase, she heard the sound of a baby laughing coming from Clermont, the older section of the house. Kirin became very nervous when she heard about the incident. Later in the same day, she mentioned the invisible baby's laughter to a tour group of her own. When the group looked into Brutus Clay's bedroom on the third floor, a toddler pointed into the room and said, "There's a baby in there!" When describing the event, Kirin wrote: "[The mother] said he didn't have any imaginary friends and that he loved babies. He was way happy to see these babies in the house until we were coming down the back stairs. As we were descending, the boy became scared as he pointed out into the

main hallway, saying, 'There's a baby out there.' Needless to say, the child scared me."

Almost a year later, Buffy had an even more unpleasant experience in the house. This time she was accompanied by another guide, Melinda. They saw a ghost that, as far as I know, has never before been seen in the house. On July 7, 2005, after the last tour of the day, Buffy and Melinda went up the mansion's main stairway in order to go to their third-floor dressing room. When they reached the top of the stairs, they saw a man walking into Laura Clay's bedroom. Buffy wrote her account soon after the sighting, while all the details were fresh in her mind:

> *I am so freaked out right now that I've chewed the skin off my fingers and I'm shaking inside...I saw who I thought was Jeffrey* [another guide] *walking inside Laura's room. He looked right at us (looking over his shoulder) and disappeared out of my line of vision. When I saw him, Melinda jerked my skirt because he'd startled her. I said, "I think Jeffrey's up here." She said, "Yeah, I saw him." We yelled, "Jeffrey." No answer. We walked into Laura's room. NOTHING. Needless to say, we freaked out. I guess because we were together, we didn't flee downstairs. Instead, we ran upstairs as quickly as possible so I could change. I think we got the lights, hopefully we didn't miss anything, but I can't be sure. I changed in .2 seconds and then we were gone. I realize now that whoever this was, he didn't have Jeffrey's hair. He was built like him though, which is why I thought it was him. I have heard things here, but never saw anything that couldn't be explained. I can't explain this and I honestly have no idea who this was. He didn't look like anyone I have seen in the books* [on Clay family history]. *Build—lean. Face—angular. Melinda said he had dark hair. I know that his hair was short. He wasn't angry looking or anything. He had no real expression on his face. But he looked like a real person, not a smoky, floating figure or anything. This all happened in about four seconds. He was wearing dark clothes. I don't understand what we saw, but we saw it and it was very, very odd and more than a little scary.*

"Very, very odd and more than a little scary"—perfect words to describe White Hall State Historic Site, a place where tourists may get more than their money's worth.

THE REAPER GETS CREATIVE

There is a fine line between tragedy and America's Funniest Home Videos.
—Kyle McQueen

There are plenty of colorful ways to die, especially for the foolhardy, the oblivious, the accident-prone, the unlucky and people bent on creative self-destruction. What follows are accounts of some of the peculiar ways Kentuckians have met their Maker. Reader, don't try this at home!

No Diagram Necessary

From *Kentucky Marriages 1797–1865*, by G.G. Clift: "Moses Alexander, aged 93, to Mrs. Frances Tompkins, aged 105. They were married in Bath, Steuben County, N.Y., June 11, 1831. They were both taken out of bed dead the following morning."

Surgeons at Ten Paces

One of the most bizarre duels in Kentucky history was fought in Lyon County on May 10, 1852. It was tradition for the challenged man to choose the weapon, usually dueling pistols,

swords or knives. In this case, the challenged party requested that he and his foe go to the local physician and have their veins slit. Presumably, whoever could stand to lose the most blood would be considered the winner. The combatants, whose names have not been immortalized by history, became too weak and pale for their own comfort and called off the duel. Both men survived, but they deserve honorable mention anyway due to their creativity and determination.

The Man Who Died in a Clock

"Aunt Patsy" Colerain lived in the Beech Grove neighborhood near Bardstown. By the mid-1890s, she was middle-aged and unmarried,

the quintessential "old maid," as such women were uncharitably called in those days. She lived with her brother, Nathan Colerain. One of their prized possessions was a century-old grandfather clock that stood in the hall and that had not worked for over thirty years. Perhaps neighbors wondered why the Colerains held onto a broken clock and why Aunt Patsy never married. Both questions had the same answer.

A generation before, when Patsy was one of the belles of Nelson County, she had been in love with Reuben Morehead, descendant of a Kentucky governor. Morehead joined the Union army when the Great Unpleasantness broke out in 1861. One night in April 1864, she received a surprise visit from Morehead. Her joy was short-lived because soon afterward, a troop of Confederate guerrillas led by Jerome Clarke—better known to history as "Sue Mundy"—came pounding at the door. The band had been terrorizing the neighborhood of late and it may be assumed that they had spotted Morehead in his Federal uniform and followed him. Thinking quickly, Patsy hid her boyfriend inside the enormous grandfather clock—but she forgot to dispose of his coat and gloves. The guerrillas were drunk when they entered the house, but not so drunk that they could not figure out Morehead's hiding place. When Patsy left the room to get refreshments for her "guests," she heard the sound of gunfire. She returned to find Clarke's men dragging Morehead's corpse out of the clock. Jerome Clarke himself had little more than a year to live before he would be dancing a midair jig at the end of a rope before an audience of thousands.

Heartbroken, Patsy Colerain never married and kept the damaged clock as a painful reminder of her lost love, its hands frozen at the time the soldier hiding within was shot.

A New Use for Wool

In late November 1877, Mrs. Davy Maggard of Letcher County committed suicide in a way that perhaps has never been duplicated:

she hanged herself from her loom using yarn in lieu of the traditional rope.

Homespun Hara-Kiri

Henry Coffman of Hardin County was tired of life—understandably, since he was eighty-seven years old. Not so understandably, he decided one summer's day to end his disillusionment in the most horrible manner imaginable while visiting his son-in-law, James Purcell. As he sat on a bed, Coffman drew a pocket knife and disemboweled himself. The press reports from the period take special care to note that he "deliberately cut [his entrails] into scraps and cast the pieces into a chamber." Purcell called immediately for a doctor, but by the time one arrived it was too late. Coffman died in self-imposed agony on August 5, 1879, three long hours after gutting himself, while his no doubt distressed, but hungry, family ate their dinner. The details of the suicide seemed so farfetched that the attending physician, Dr. J.D. Strother, felt compelled to write a press release confirming them.

Why Cats Are Sometimes Best Left Outside

Warning: The following story is disagreeable. Rats are infamous for their tendency to gnaw on the dead if they get a chance—as is our alleged friend, the domesticated housecat. Hence, a horrifying tale that made the rounds of the press in February 1881, concerning George Pieratt of Salt Well Branch near Owingsville, Bath County. The elderly bachelor's sister, Elizabeth Goodpaster, was paralyzed and confined to a bed in his house. One evening, Mr. Pieratt tried to toss a log in the fireplace. It proved too heavy for him and he fell in. Through extraordinary willpower, Mrs. Goodpaster managed to get out of bed and pull his burned body out of the fireplace and onto the hearth. Exhausted, she could move no longer and spent the better part of a day watching ungrateful and opportunistic

cats dine on her dead brother's ears, nose, eyes, cheeks and throat. At last, she was rescued by her son when he dropped by for what he wrongly assumed would be a pleasant visit.

Death in an Outhouse

On the night of July 18, 1882, a Louisville woman named Nancy Miller and her three-year-old daughter, Florida, died "under circumstances almost too revolting for publication," in the words of the *Courier-Journal*. The two entered the outhouse that served their tenement home at 1030 Ninth Street. The rotten floor gave way, pitching them into the filthy muck ten feet below. By the time help arrived, the two had drowned in the outhouse vault. Their bodies were recovered "after considerable trouble."

Determination Is a Virtue

Twenty-five-year-old Tom Hanlon was an inmate in the Louisville jail, drying out after an attack of delirium tremens. On July 17, 1885, he decided that he was tired of this wearisome parade called life and astonished jail officials with an imaginative and grisly suicide attempt. Hanlon smashed the window in his cell and seized a triangular piece of glass almost a foot long. In the presence of horrified onlookers, Hanlon stabbed himself in the left side near his heart with the homemade weapon, reached into the wound with his fingers and—after digging around for a few moments—pulled out a substantial piece of his lung. The *Courier-Journal* thoughtfully included an illustration depicting Hanlon's triumph. He was taken to a hospital and the next day, during an unguarded moment, Hanlon tore the plasters and dressing off his wound. Doctors caught him again exploring the wound with his fingers. Somehow, he managed to linger in this vale of tears until July 25. Just before he died, he repeatedly asked doctors for a pen knife "with which to pick his teeth"—or so he said.

Hidden in a Horse

Mr. John Keeth of Green County attained an unenviable measure of brief fame when his murdered corpse was found stashed in a strange hiding place. Keeth disappeared in January 1887. On February 5, a dog came trotting to the home of William Despain, Keeth's brother-in-law, proudly carrying a human hand. Despain followed the dog to the carcass of a horse that had died shortly before Christmas and found Keeth's body wrapped in a blanket, stuffed into the hollowed-out horse's body and half eaten by dogs. The sleazy national newspaper *Police Gazette* ran an unpleasant illustration depicting the discovery of the body.

The Man Who Tried to Fight a Train

James Wilkens, a prominent though drunken citizen of East Bernstadt, Laurel County, went on a bender on November 11, 1887. Witnesses saw him reeling around, full of aggression and threats, and spoiling for a fight. At one point, he swore at a farmer's wife who tried to help him up after he had passed out near some train tracks: "I am not afraid of man or anything else in this world [expletives deleted], and I'll prove it to you. They can't fool with me!" So saying, and without clarifying who "they" were, he staggered onto the railroad track and faced down the oncoming eastbound Louisville & Nashville only a hundred yards away. He stood with his hands upraised, shouting at the train, "Come on, you [expletive deleted], I'm not afraid of you or anything else!" When last seen, Wilkens was diving headfirst like a catamount at the locomotive's cowcatcher.

A Slightly Foolish Wager

The day was fine, but cold—Saturday, January 12, 1889—and John Owsley, a twenty-two-year-old coal driver in Louisville, was thirsty. This was his usual state, as he was an alcoholic. As fate would have it, he saw a friend equally fond of drink, Milton Geoghegan, out on the street. The pair went to saloon after saloon, each treating the other in turn to beer and whisky. By the time they staggered their way to Thirty-Fourth Street, both were drunker than boiled owls. They began arguing over a question that inevitably arises when two or more men imbibe alcohol: Which one of us can hold the most liquor? Each maintained that he could drink more than the other. Their friendly debate turned into an argument; the argument became a fight, broken up only by members of a gathering crowd. Someone came up with a diplomatic solution: "Toss up a coin, the lucky man to first choose a test for his companion."

Geoghegan won the coin toss and declared that he would admit Owsley was the better man if he would drink all the whisky Geoghegan could buy. Owsley agreed to the terms and off they—and various deeply interested bystanders—went to Frank Leoty's bar, ironically located on Water Street. Geoghegan purchased a half-gallon of inferior-grade whisky for $1.35. As the crowd watched, Owsley drank it all in less than four minutes.

At first, Owsley seemed unaffected. After some conversation with friends, no doubt on weighty matters, he stepped outside to take in the air. Boatmen found him an hour later on a wharf, unconscious and twitching. Owsley's friends carried him to his home at Nineteenth and Pyrtle Streets, where, despite ministrations from a doctor, he died on Monday "after enduring horrible suffering." But at least he won the bet. Almost exactly a week later, his friend Milton Geoghegan was killed by a sore loser after a night of gambling.

One of the best things about newspapers, as well as the online "Darwin Awards," is that they serve up a daily ration of cautionary tales. When we read about some reckless stunt that goes awry, we have been warned of what may result should we also try it. Of course, there are those who refuse to take heed, at their own peril. Although John Owsley's demise received wide coverage in the Kentucky press, only a few months later Bill Slinker of Horse Cave, Hart County, thought he would prove his mettle by drinking a gallon of whisky and six buckets of ice water within twelve hours. His obituary is worth quoting as a deterrent: "His sufferings were intense, and nine hours after he died blood issued from his nose and mouth in a stream." Slinker's death received enough national attention to inspire a callous joke in the *Chicago News*: "It is difficult to see anything peculiar about the death of a Kentucky man who had been so injudicious as to drink water."

Scared to Death

The citizens of Bellevue, Campbell County, were spooked by an alleged ghost that appeared nightly in a room over Boro's Grocery. On August 31, 1889, Mrs. Angela Rusconi, one of the richest women

in the state, came to see it. When the spirit made its regular rounds, she was so terrified that she died of fright. It might offer poor Mrs. Rusconi some dignity if we could say that she was one of the few persons in history to be scared to death by a genuine ghost, but that claim to fame must be denied her. A few nights after her death, investigators discovered that the so-called ghost actually was the reflection of an electric light at a nearby river landing.

Mission Accomplished!

Josie Lonsford, uncharitably described as "a weak-minded girl," committed suicide in Laurel County in early November 1893 in a manner guaranteed to make her the talk of the neighborhood for years. She placed a meat axe on the floor, edge facing upward, and pressed it between two blocks of wood so it would remain upright and sturdy. Then she blindfolded herself, evidently to spare her dainty feelings, and sawed her wrist back and forth over the dull blade until her hand was nearly severed. She bled to death.

"The Most Peculiar Disease"

The following obituary from the *Richmond Register*, circa January 1894, is hard to surpass for real-life surrealism:

> *The particulars of one of the most remarkable cases on record come from Knox County, in this state: John W. Eggleman, a well-to-do young farmer living near the Clay County line, died Saturday of the most peculiar disease ever known in that vicinity. About four years ago while in the field he got very sick, and in a few minutes he was stricken down, not being able to move any part of his body, though he had feeling and could see, speak and hear as well as ever. Since that time he has been perfectly helpless. Before his death for quite a while he could not swallow anything, and he gradually starved to death,*

surrounded by friends. For about a year before he died the only things that kept him alive were liquids, which were placed in his mouth, his head pushed back and shaken. This was the only way anything could be got down his throat. His head and limbs could be placed in any position, and would remain so until changed by someone. They seemed to be on pivots, similar to a doll.

Kentucky Crucifixions

The wires were abuzz with news in August 1894 that an unnamed prostitute had been crucified near Goose Creek in Clay County—that is, nailed to a tree through her hands and feet. Her alleged tormentors were other women of ill repute. A similar story came from Elliott County almost a year later, in July 1895, when it was widely reported that a young woman named Carrie Jordan had been "repeatedly assaulted" by three ruffians in an abandoned cabin, who then choked her into insensibility and, after extending her arms, nailed her hands to the cabin wall. Since there were no follow-up stories for either of these sensational reports, they may have been journalistic hoaxes.

Tongue Twister

Peter Pepper, formerly a barber, and more recently a drunkard and a lunatic, had had quite enough of life's fitful fever. As he sat in his room in Louisville's City Hospital, he decided to end it all. But how to do it when he was being so closely watched by attendants? Pepper might have been crazy, but he was clever enough to think of an effective method that probably had never before been attempted by anyone in the history of the world: he seized his tongue with both hands and partially pulled it out, resulting in a catastrophic loss of blood. His tongueless spirit wafted to its reward on the evening of November 8, 1894.

Listen to Your Instincts

On the morning of April 4, 1895, Joseph J. Willis was oiling the bearings on a machine at the Louisville Veneering Mills Company, part of his job as chief engineer, when his coat sleeve got caught on a shaft pulley screw. The machine happened to be running. Willis was yanked up into the air and in less than a second was being whirled around to the tune of 250 revolutions per minute. As he spun around, his body repeatedly struck the ceiling and a steam pipe over the shaft. The noise caught the attention of a superintendent, who turned off the machine and went to investigate. He found Willis's corpse sticking out in the air at almost a right angle to the machine, since his coat was wound so tightly around the shaft.

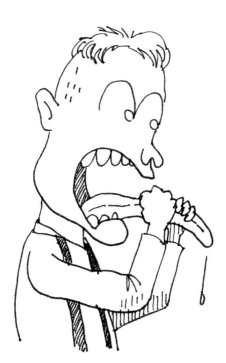

That very morning, Willis had told his wife that he didn't feel like going to work. She expressed a sense of foreboding and begged him to stay at home. Willis replied that he would just go oil the machines, and then come straight home.

Chamber (Pot) of Horrors

Walter Hahn of Muhlenberg County, an inmate at the Western Kentucky Asylum for the Insane in Hopkinsville, met a dreadful death at the institution in October 1897. He fell off his bed during a seizure and got his head stuck in a chamber pot. Hahn "was stifled *or* drowned," as a newspaper account delicately phrased it. Italics are mine.

A Remarkable Display of Stamina

Will Emery of Louisville got peeved on Christmas morning 1898, when his live-in girlfriend, Harriet Day, refused to give him money. He registered his annoyance by stabbing her in the neck with a large knife and running away. A neighbor tried to help by caulking the wound with an unsavory mixture of soap, sugar and clay. Miss Day wrapped a muffler around her neck and then took a two-mile unassisted walk to the City Hospital. She made it as far as the grocery store across the street from the hospital; there, she sat down on the stoop to rest. Someone noticed her distress and notified the hospital. She was carried to the building on a stretcher, but died just as she crossed the hospital's threshold. The knife wound had been so well disguised by the neighbor's unorthodox first aid treatment that the coroner and the hospital staff had to examine Day's body three times before they figured out what had killed her.

You First!

Miss Tammie Church of Gallatin, Tennessee, visited her cousin, Miss Florence Johnson, at the Johnson family's home on West Broadway Street, Louisville, on the night of January 17, 1899. Both girls were only sixteen and evidently full of foolish, romantic notions. Miss Church was upset because she had not lately received a letter from her boyfriend—a ne'er-do-well railroad brakeman back in Tennessee. Suicide seemed the only sensible option to her, so she procured morphine. Miss Johnson decided that she would also commit suicide for no other reason than to show her dolorous cousin a little support. Between them, they swallowed twenty grains of the drug, enough to kill a score of people. Miss Johnson survived to tell the tale; Miss Church did not.

Axe-ident

On the first day of March 1899, Grayson Countians had their complacent belief in the orderly scheme of things shaken by a gruesome mishap. Sixteen-year-old Tim Crail and his friend Alex Hunter were engaged in the wholesome, healthy exercise of cutting railroad ties about a mile south of Leitchfield. Hunter's axe hit a tie with a glancing blow, causing the implement to bounce up and strike Crail in the neck. Crail was nearly beheaded, but that misfortune did not prevent him from running fifty yards to a fence, where he fell and died.

Bridge to the Other World

Tom Haevey was a fifty-five-year-old Irish immigrant who lived in Louisville at the turn of the last century. He had an unhealthy obsession: he believed with all his heart and soul that he could jump off the Big Four Bridge and survive. For months on end, it was said,

leaping off the bridge was all he would talk about. At last, one muggy August morning, Haevey was determined to show the bridge who was boss. Our quixotic hero left a saloon (significantly, perhaps) and walked to the site of his mania with two witnesses in tow. Haevey's leap was a thing of beauty—at first. He plummeted through the air, feet gracefully pointed downward. Then, about halfway down, his body turned. He hit the water face first and the world learned that Tom Haevey could not successfully jump uninjured from the Big Four Bridge.

A Succinct Obituary

A death notice in the *Louisville Courier-Journal* of October 22, 1899: "Glasgow, Ky., Oct. 21. Luther Johnson, a young farmer living in the southern part of this county, blew into the muzzle of a shotgun early this morning to see if it was loaded. It was."

Shotgun Santa

Jacob Hunlow of Grayson Street, Louisville, dressed up like Santa Claus at a family gathering on Christmas Eve 1899 in order to delight his children and his friends. His brother-in-law, John Biechner, handed Hunlow what everyone assumed was an unloaded double-barreled shotgun, stating that Saint Nick ought to have some means of protection if he was going to be carrying all those pretty, pretty presents. When Hunlow playfully aimed at a toy on the Christmas tree, the shotgun discharged, killing Mrs. Hunlow and undoubtedly instilling in the children a lifelong fear of Santa Claus.

His Last Practical Joke

Charles Koertz was a teenage clerk at R.L. Potter's restaurant in Paducah, McCracken County. One brisk evening in November 1900, he spotted what he took to be an empty Colt revolver on the counter, left there by Mr. Potter. Koertz, obviously a classy guy, decided it would be a fine idea to play a practical joke on his boss's four-year-old son. Koertz held the gun to his chest and said: "Willie, watch me shoot myself!" It does not require much imagination to guess what happened next.

A Comprehensive Demise

On the night of March 16, 1901, two coon hunters in eastern Bath County, James Highley and a man unnamed by the press, thought they had gotten lucky. Their dogs had treed some animal in a large poplar tree. Highley climbed the tree to capture the alleged raccoon. He found himself face to face instead with a peeved wildcat. After a Homeric struggle in the treetop, both man and beast fell about two hundred feet, since the tree happened to be located on the edge of a cliff. Highley and his feline adversary hit the ground still locked in a death grip—and then the dogs attacked. Highley was "literally torn to shreds," leaving the coroner to wonder whether he had been killed by the wildcat, the fall or the dogs.

Take Pride in Your Work

Tom Turner of Louisville desired to put an end to all his earthly cares by hanging himself. Not just any old attic rafter would do, however; Turner evidently wanted to make a spectacle of himself. On the night of June 28, 1901, he went to the center of the floral park on Ormsby Avenue and climbed to the highest branch of the tallest cottonwood. He shinned out to the end of the branch, tied one end of a rope to it and the other end around his neck and then jumped. When Coroner McCullough arrived next morning, he found a crowd of at least five hundred people staring agog at Turner's body, which swung in midair forty feet above the ground. Volunteers had to undergo painstaking and precarious efforts to retrieve the corpse.

The Fruits of Impatience

G.W. Steen, a Louisville tobacco broker, wanted to try out his recently repaired Marlin rifle on July 23, 1901. The problem was

that, rather than go to the woods outside the city like a sensible being, he thought Jefferson Street was a perfect place to shoot at birds. He killed a sparrow just outside the repairman's shop. Despite a warning from a bystander that he should find a more appropriate location to go hunting, Steen fired a second shot at another sparrow. Then he sought other game in the form of a pigeon on a rooftop at Ninth and Jefferson Streets. Steen took aim. Steen fired. Steen missed. A passerby named William Hobson paid for the shooter's carelessness with a bullet through the heart.

That Did It

Lee Rice, a prominent farmer and auctioneer of Wyoming, Bath County, wanted to kill himself in the worst way. He had made three unsuccessful attempts and each time had been sent to a private sanitarium and discharged as "cured" of his suicidal mania. He proved the authorities wrong on August 26, 1901, while watching some workmen blow up stumps with explosives. Inspired, Rice put a stick of dynamite in his mouth and lit the fuse. The percussive power of the charge literally vaporized his head.

Rather a Bad Idea

In March 1902, construction workers were making room for an extra track on the railroad in Somerset, Pulaski County. It was a raw day, so someone placed three sticks of dynamite by a fire so they could thaw out. Two teenage boys—Vester Simpson and James Green—happened to be present when the dynamite had warmed sufficiently. The papers do not mention whether Simpson and Green had the brilliant idea to use fire to thaw explosives or whether they were just in the wrong place at the wrong time, but the results were crystal clear: Simpson was blown seventy-five feet through a wire fence and Green landed in some telegraph wires.

Life Imitates a Wile E. Coyote Cartoon, Part One

William Hewlett, a Lawrence County farmer, met a cartoonish fate on June 2, 1902. Hewlett sat on a log and supervised as some men cut down a tree that stood on the edge of a small cliff. The tree fell the wrong way and struck the edge of the log on which Hewlett was sitting, propelling him into the air. He landed on his head at the edge of the cliff and then rolled over and fell to the bottom. He died from the resulting injuries.

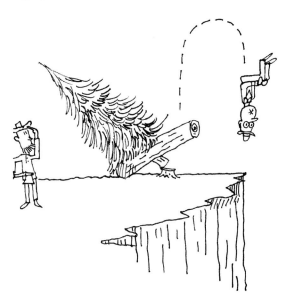

Safety Tip: Always Check Your Pistol Before Aiming It at Your Head

Young Joe Karnes of Columbia, Adair County, had the obnoxious habit of snapping his pistol. On the afternoon of June 4, 1902, a friend

asked him to please cease and desist after Karnes had done it several times, adding that the gun was loaded. In a moment of ill-advised machismo, Karnes said, "I am not afraid to snap it against my head." His obituary concludes: "He did so and was buried this afternoon."

Hoisted by His Own Petard

Thieves had been stealing with impunity from Mr. Thompson's corncrib in Lebanon, Marion County. The farmer's son, James Ben Thompson, set a diabolical booby trap: he arranged a loaded shotgun in the crib so that when the door was opened, the intruder would receive an unexpected present in the chest. Sadly for young Thompson, he forgot about his own trap and when he went to get some corn one morning…

Killed by the Power of Suggestion

Eli Bozarth of Hawesville, Hancock County, thought the water he drank from a pool tasted a little funny. Upon closer inspection, he found a defunct snake in the water. Bozarth, clearly a man of powerful imagination, was certain that he had consumed poison from the contaminated water. After weeks of convincing himself that he was about to die, a contemporary paper explains, "the mental agony this caused brought on a serious physical condition which resulted in his death" around June 1, 1905.

The Fatal Toy Cannon

Fifteen-year-old George Irving Harper of Louisville decided to celebrate Christmas 1905 by setting off a toy cannon made from a steel axle. First, he packed a quarter-pound of powder into the

muzzle, using a piece of broomstick a foot and a half in length as the ramrod. The powder exploded prematurely after being touched off by a lit firecracker thrown by George's brother. The broomstick was driven through Harper's head, killing him instantly.

On the same holy day, two other Louisvillians were maimed by toy cannons: Spanish-American War veteran Thomas Bibbs, thirty-six years of age and therefore old enough to know better, who lost both his eyesight and his left hand while attempting to pound an enormous firecracker into the barrel of a small cannon, using a steel axle as a makeshift hammer; and Fred Dries, age fifteen like Harper, who got off lucky with mere severe burns about his head, face and arms.

Life Imitates a Wile E. Coyote Cartoon, Part Two

William Ford of Lawrenceburg, Anderson County, occupied himself by blasting things with dynamite on November 30, 1906. One stick

failed to detonate. Ford went over, picked it up and contemplated it with curiosity. Then it did.

An Unseemly Prank

Clara and Annie Osgood, young sisters of Reedville, Boyd County, had a disagreement concerning the existence of ghosts. Clara claimed that no ghost could frighten her and was so confident in her own bravery that she wagered a new silk petticoat. Annie waited several days until she was sure Clara had forgotten the bet; then Annie wrapped herself up in a sheet and woke Clara out of a sound sleep on the night of October 16, 1907. Clara was so distraught that she jumped out a second-story window and broke her neck when she hit the ground.

The Reaper Gets Frustrated

For a refreshing change, let us consider James Billiter of Williamstown, who spent a lifetime foiling the Reaper's most creative efforts to bring about instant death. He was born in Grant County on September 19, 1827, and had his first major accident at age thirteen, when he fell off a horse and fractured his skull. Everyone gave him up for dead but eventually he recovered. As a young man, he worked as a carpenter; one fine day in 1844, he fell thirty feet off a house he was constructing. Suddenly, his body was suspended in midair. Rescuers found that he had caught his chin on a nail on the way down, an event that does not sound very enjoyable, even if it did spare his life. In 1861, Billiter was bitten by a mad dog. Neighbors applied a madstone to the wound. Perhaps the folk remedy worked, because Billiter never suffered any ill effects from the bite, though in that day rabies was as good as a death sentence.

The Death Angel's next foiled attempt occurred in 1867, and is reminiscent of a scene in the film *Alien*:

While drinking from a stream of running water...he swallowed a foreign substance. It began to give him discomfort in a few days, and in about a week he began to spit up blood and complain of a continual clawing in his stomach. He went to a doctor and the physician gave him an emetic, when he threw up a live crawfish, and at the same time great quantities of blood.

In 1872, while building the four-story Odd Fellows' Temple in Williamstown, Billiter underwent a second spectacular workplace accident when he fell from the roof and landed headfirst on a pile of rocks in the cellar, a distance of forty feet. This time he was badly injured, but after a while he completely recovered and did not bear so much as a scar. A biographer notes: "In 1884 Jim had the smallpox, and he has had almost every contagious disease in the calendar. He is yet hale and hearty and expects to live to a ripe old age." Billiter estimated in 1901 that he had spent more than $10,000 during his life on medicine and doctors' bills.

THEY PREDICTED THEIR OWN DEATHS

In addition to his many other achievements, Mark Twain also accurately predicted his own death. Halley's comet soared overhead when he was born in 1835 and he always believed his life would end when the comet came back. Twain died in 1910 as the comet reappeared after its allotted seventy-five-year absence. A pretty neat trick, one might think, but many people have predicted their own demise with uncanny accuracy. Some have even been Kentuckians.

In March 1880, Mr. Tillman Pierce died at his home on Meeting Creek, Hardin County, after a long illness. Much to his family's surprise and discomfiture, Pierce disrupted his own funeral by suddenly sitting up in his casket and announcing that he had visited heaven and hell while temporarily dead. After describing these places, specifically their climates, he said that he would die again in one day and then would rise again three days afterward. After this final curtain call, he said, he would die and stay dead. Pierce did die at the end of the day, but whether he revived three days later, no one can say. Let's hope he did not, for his spooked family quickly had him buried "fathoms deep." If he did rise again from the dead, an unpleasant surprise awaited him.

A case reminiscent of Tillman Pierce's occurred when Rinda Richie of Hindman, Knott County, died in September 1896. Or at least she put on a good show. After she was dressed in her burial clothes and coffined, Dr. J.T. Walker noticed signs of life and

managed to revive her. The fact that she had just missed becoming a victim of premature burial seemed not to trouble her. To the contrary, she happily told everyone that she had been to heaven. She further astonished friends and family by telling them that she would die for good in a month. Mrs. Richie spent that month in continuous prayer; true to her word, she passed away on October 16.

The story of John Waldburger is a strange mixture of cold feet, unkept promises and a woman's preternatural persistence. In 1881, while immigrating to America on a steamer, Waldburger met a woman named Elizabeth Gander. They must have hit it off pretty well since Waldburger promised en route that he would marry her. But when the ship docked they went their separate ways: Elizabeth to Louisville and John to West Virginia, where he became a carpenter. In 1888, he joined the Swiss colony in Laurel County, Kentucky; in 1891, he lit out for the Indian Territory. All this time, he was still engaged to Elizabeth Gander and corresponded with her, but they remained unmarried, as he felt he had not sufficient income. At last, Miss Gander grew tired of the arrangement and after eleven years of being engaged, she told Waldburger he must come to Louisville and marry her, no matter how impoverished he might be. The blessed event took place on Saturday, March 12, 1892, at Gander's Shelby Street home. While the guests congratulated Waldburger at the reception, the groom expressed a wish that he would die in a week. Eight days later, he was dead at age forty-three of what the doctors called "softening of the brain"—that is, a stroke. The minister who had performed the wedding ceremony also officiated at the funeral.

Andrew Vaughn—a farmer, Mexican War veteran and original California Forty-Niner—lived in Harrodsburg, Mercer County, where he was a much-beloved local character. He alarmed friends by accurately predicting weeks in advance that he would "answer death's bugle call" on August 27, 1895.

In December 1896, Isaac Bullen's sister died in Rockcastle County. He remarked, "One week from today I will be buried." He was right. Bullen obviously was a fellow who liked to be prepared, for he had had his burial clothes and casket made to order twenty-five years before.

Thomas Marshall, originally from Louisville, was at work in a St. Louis poolroom on April 30, 1897, and was discussing a Memphis horse race with his friends. Marshall was especially excited by a contestant named Algol, stating, "I'd stake my life on that horse." He even went so far as to place a bet that Algol would finish first. An hour later, the news came over the wire that the horse had lost. Marshall fell unconscious at his desk and died later that night. I suppose that means he did not have to pay his wager.

George W. Nall attended a barbecue at Clay, Webster County, on July 31, 1898. While walking to a lemonade stand with Thomas Page, the county jailer, Nall remarked, "I will be a dead man in less than twenty minutes." Thus saying, he collapsed and was dead within a half hour. Nall's dramatic demise might be explained by the fact that he had had a long history of heart trouble.

On New Year's Day 1900, George Vetter of Ludlow, Kenton County, boldly stated that he would not live to see 1901. Five days later he was dead, seemingly of natural causes.

Mrs. W.A. Roberts, a young wife in Bardwell, Carlisle County, claimed to have had a psychic dream that foretold that "some great man would be shot and that in one week from the time he died, she would die." But she didn't tell any of her friends about the dream until Kentucky's Governor Goebel was shot on January 30, 1900. Naturally, her skeptical pals scoffed, believing that she had made up the dream after the fact. But they ceased laughing when Mrs. Roberts became ill a few days after Goebel was shot. Goebel died on February 3, and Mrs. Roberts died of blood poisoning on February 10, precisely a week after the governor's demise. She left behind a husband and two children.

In 1903, Letitia Barret died of gastritis at her home in Warfield, Martin County. Evidently, she had had a feeling for some time that her death was impending. Months before, while still in good health, she had secretly made and hidden her burial clothes. She also wrote a note and hid it in her pillow. As she lay dying, she told her friends and her husband, attorney J.D. Barret, about the location of the note and asked them not to read it until she had passed away. After that sad event occurred on January 13, they opened the letter and read these

instructions from the grave: "I want Lillie Barret and Mrs. Helen L. Barret to dress me. You will find two skirts, a gown, an undershirt and pair of white hose in the middle bureau drawer. I do not want any shoes or slippers on my feet."

Louisvillian Henry Kremer took ill on March 19, 1903. He remarked that it would be strange if he died on March 25, the fifty-year anniversary of the day he lost his right arm in a hunting accident. On March 25, the Death Angel proved to have a sense of historical irony.

Lula Carter Fowler of Louisville was so certain her death was imminent that on the night of Saturday, June 24, 1905, she confided her desired funerary arrangements to a neighbor, Mrs. Mildred Biechner. Mrs. Fowler came down with peritonitis the next morning after attending church. She answered the summons in her West Walnut Street home on the night of June 25 after an illness of only ten hours.

A third Louisvillian, barber William Baisch, came down with pulmonary tuberculosis in March 1906. Since the disease was almost always fatal, it is not surprising that Baisch had a premonition that the Reaper was beckoning, even though he was only thirty-four years old. What is surprising, and more than a little eerie, is the precision with which he predicted the moment of his demise. On the night of Sunday, May 6, 1906, he told his wife that he would be dead by 8:00 p.m. on the coming Wednesday. He died at 8:00 p.m. on Wednesday, May 9.

On February 28, 1913, Dr. John Franklin Bull Lillard of Mercer County stated with confidence that he would die on the Fourth of July. He did exactly that on the predicted day at the age of sixty-one, only a half hour before midnight.

The most distinguished Kentuckian ever to amaze others by revealing his own death date was former Governor Luke P. Blackburn. On September 9, 1887, as he lay on his deathbed, Blackburn overheard a doctor say that he could not live another hour. Blackburn announced, "I will only be with you five days; tell all my relatives and friends." An account in the *Atlanta Constitution* has the dying man making an even more precise prediction: "I will die on September 14 at 2:30 p.m." Blackburn

did exactly that. Perhaps Blackburn, himself a physician, had been able to predict his demise with such accuracy by observing his own symptoms.

SOME BLUEGRASS GHOSTS

The Haunted Bee Gum and the Boisterous Coffin

In August 1887, the *Richmond Climax* in Madison County ran a ghost story "vouched for by numerous responsible persons." In 1884, John Ballinger of Big Hill accidentally shot his little daughter. She lived just long enough to run from the house and into the yard, where she collapsed on a long plank of wood and died. In 1885, a man named McSweeney purchased the piece of timber despite its tragic history and made it into a bee gum, yesteryear's name for a wooden beehive. (Tammy Horn explains in her authoritative book *Bees in America* that bee gums got their name from the fact that pioneers liked using black gum trees as beehives because they decayed interiorly and were easy to hollow out.)

McSweeney soon noticed a problem with his pride and joy: bees refused to stay in it, which rather defeated its purpose. He noticed that a knocking sound emanated from the gum, "as if some person were rapping on a door, only there was but one knock at a time, and the intervals were some minutes." The puzzled farmer assumed that the sporadic noise was scaring away the bees. A bee gum is hollow, it will be remembered, so there should be nothing inside to produce such unnerving sound effects. After being mystified by the gum for some time, McSweeney put it up for sale.

The next owner was Reuben Cox, who lived near Mallory Springs. Neither he nor two other men, a Mr. Scuttle and Cy Baker, could induce bees to stay in the gum. Cox claimed the knocking sound was occasionally so loud that he could hear it across the road. He also noticed that it was more frequent during certain seasons and that it occurred most often at night. The *Climax* article ends with Cox offering to give up his farm if the bee gum failed to behave exactly as advertised. There is no record of anyone taking him up on his wager.

Another story featuring unexplained knockings unfolded in Muldraugh, Meade County. In 1886, Zach Gill got into an argument with a widow named McCarty concerning the ownership of a cow. Gill ended the debate with a shotgun riposte. The noted doctor Henry Pusey testified at the trial that the murderer was insane, so instead of going to jail Gill ended up in the asylum at Lakeland. He died there around 1888. His body was taken home for burial in a coffin provided by the family, while Gill's clothes and meager worldly possessions were packed away in a rough wooden coffin provided by the state. Zach Gill's widow refused to give these items to Zach's brother Tom; instead, she kept the coffin in her attic. When the widow died in 1897, Tom Gill immediately took possession of the coffin and gave away the bits and pieces of his brother's estate inside it, despite the protests of Zach Gill's son, who thought he should have claim to all the items. Having nowhere better to place the coffin, Tom put it out on the porch, where it invited comment from passersby.

All was pleasantly mundane until July 1897. Tom Gill was frequently awakened by the sound of someone knocking on the door, which happened to be located very near the coffin. Whenever he opened the door, no one would be there. Thinking it to be a prank, he stood by the door in a state of readiness, prepared to fling it open the next time he heard the knock. When that occasion came, he opened the door immediately, but to his amazement no one was there. Nor did any pranksters have sufficient time to flee or hide. Tom was still scratching his head over that one when he realized that he could hear a tapping noise coming from inside the coffin. By lantern light, he opened the lid and examined the few items

that remained within—some of Zach Gill's clothes—but he found nothing that could have caused the sound. The instant he closed the lid, the rapping recommenced.

After that incident, the coffin's sound effects came daily and nightly. Gill was visited by hordes of people who wanted to hear the knocking. Muldraugh was a summer resort for wealthy city dwellers and when word about the magic coffin got out, fifty boarders at the Twin Caves Hotel held nightly parties on Gill's porch. Nothing was ever found inside the coffin to account for the rapping sounds. A contemporary news article states, "The ignorant say that it is the spirit of old Zach Gill trying to tell to whom the clothes should be given. Of course the enlightened visitors and the intelligent inhabitants of Muldraugh do not believe a spirit is responsible for the sounds, but they admit that they are unable to discover just what does cause them."

A Ghost Comes to Church, Maybe

In September 1891, a Baptist revival took place in Lincoln County. Every night for two weeks, the small church at Ephesus was packed with worshipers who came to hear the exhortations of local preachers. Everything went well until the evening of October 1.

The speaker that night was the elderly Reverend W.T. Reynolds, who had been a preacher of the Gospel for half a century. His reputation as a speaker was so great that the church was "crowded almost to suffocation," according to one account. Every now and then, the listeners would be relieved by cool breezes blowing through the window that faced a cemetery behind the church.

Reverend Reynolds's oratory grew more heated and eloquent as the sermon progressed and his listeners became correspondingly more entranced. At last, the preacher gestured with his arm and shouted, "Behold the Lamb of God, that taketh away the sin of the world!" At that moment, the spectators realized that an eerie figure had become visible behind Reynolds. It was not the Lamb

of God. The presence walked in complete silence to the altar and leaned on it. Reports described the figure as tall, spectrally pale and dressed in a white robe. People were disturbed by its "eyes of flashing brilliancy."

For a few moments, the preacher and the congregation stared in horror at the figure. Then a tidal wave of wild panic swept over the listeners, who rose as a single body and headed for the door. Some even leaped through the windows. Reynolds was so terrified he could not bring himself to look further at the apparition. After a few seconds, he fled the pulpit and joined the terrified parishioners outside.

Nobody was hurt in the rush for the exits, but the church was abandoned for the night, as no one dared to enter the building and investigate. The lamps were left burning before the empty altar.

No one ever reported seeing the ghost again. Of course, the incident might have been a malicious practical joke, but it's a lot more fun to imagine that it wasn't.

The Beautiful Ghost

A tale complete with impressive detail, multiple sightings and a reliable witness was published in the *Cadiz Telephone* in February 1890. The witness was Thomas K. Torian, a livery stable owner "known to nearly every man in Trigg County, and [having] a wide circle of acquaintances extending over a large part of this section of the state." The *Telephone* described him as being "a plain, practical, intelligent gentleman, sober and truthful, and little likely to allow his imagination to mislead him." One evening, Mr. Torian and his carriage driver went to Gracey, Christian County, in order to meet Mrs. Torian, who was returning from a visit to relatives in Russellville. As they made their way back home along on the Cadiz and Hopkinsville road, they passed a small cabin by the roadside, about three and a half miles east of Cadiz. Torian's driver called his attention to a form, seemingly a woman, near the cabin.

The panicked driver immediately took it to be a ghost and said so. Mr. Torian, fearing that his wife would get scared, curtly told the driver that it was only a resident of the cabin. Inwardly, however, he must have had his doubts, for he leaned out the carriage window to get a better look—while at the same time deliberately blocking the view from his wife in order that she might not be frightened. Torian saw that a wraithlike woman wearing apparel rather risqué for the era was now standing only about twenty feet from the road. She turned to face him. Torian later claimed that he never saw a more beautiful female figure or anyone more graceful in bearing and movement than this strange creature. She wore only one garment, which reached a little below the knees, sleeveless, apparently cut low at the neck, and as colorless as the whitest and purest of marble, as were also her features and all portions of her limbs exposed to view. Her hair, long and luxuriant, was

unconfined and reached far below the waist, and, like the rest, was of shimmering whiteness.

Torian could compare her only to a beautiful marble statue come to life. The woman folded her arms across her chest, turned and walked slowly away toward a fence surrounding a nearby cornfield. The carriage clattered on another twenty or thirty yards before Torian decided he had to have another peek at the woman, if woman it was. He looked out the window again, expecting her to be far behind them, but to his amazement she somehow had nearly caught up with the travelers and was standing in the road only about thirty feet behind the carriage. This time, Torian was satisfied. He closed the window curtain and swore he would never mention the incident to anyone.

His driver, however, told some people about it and mentioned that Torian had witnessed it too. The feline was out of the haversack, so to speak, and Torian had a choice: either deny that he had seen anything or admit it. He chose to be forthcoming, even allowing the *Cadiz Telephone* to print his name when it ran an account of the sighting. It soon came out that Torian was in good company. Several other people in the community had seen the phantom and, unlike most ghosts, which tend to haunt only a single area, this one was something of a rover. For example, an anonymous farmer who lived several miles from the Cadiz-Hopkinsville road had a strange encounter with the being the night after Torian saw it. He heard his farm bell ringing and when he went to investigate he saw the attractive, glowing female ghost gliding away from the bell rope. She abruptly vanished before the astounded farmer's eyes. Shortly thereafter, two men saw her a short distance from the location of the Torian sighting. Three nights after her appearance before Torian, she was sighted, not on a forlorn farm or on the lonely highway, but in the town of Cadiz.

The article made a point of noting that Thomas Torian considered "all things bearing even a semblance of the supernatural as ridiculous in the extreme." Yet he was at a loss to explain what he, his wife, his driver and other independent witnesses had seen.

The Stringtown Inn

In January 1901, the *Corinth News* ran a tongue-in-cheek report on an alleged haunted house that stood five miles east of Stringtown, Grant County, on the highway between Cordova and Cynthiana. In antebellum times, the twelve-room house had been a combined inn and saloon and a favorite stopping place for farmers driving their livestock to Cincinnati. It was a scene of card games and drunken revelry that often ended in violence. At some point after the inn was abandoned, a mysterious couple of unknown origin moved in. They moved out within a few weeks, but after they left passersby saw "ghostly lights…dancing through the rooms at night." The lights were complemented by the sounds of screaming and hysterical laughter. Everyone had the good sense to stay away from the inn, except for two young men who vowed to stay an entire night there. According to the *News*, "The next morning they were found some distance from the house chattering in maniacal frenzy. It was weeks before they were able to give any coherent explanation of their experience, and then they only said they had been seized by giant arms, their clothes torn from their bodies and themselves hurled through a window." Sounds somewhat like a rowdy fraternity initiation, but after the young men's tale of being disrobed and defenestrated by ghosts was made public, locals were more reluctant than ever to investigate the decrepit building.

The Old Bailey House

Two miles north of Dunnville, Casey County, there once stood beside the road between Jamestown and Somerset a structure known as "the old Bailey house." It was a very decrepit and very large building that allegedly had been an inn in better times. Early in its history, it was a hangout for a gang of counterfeiters who were thought also to be robbers and highwaymen.

The house remained empty for years. In late March 1897, William Turner and his family moved in. On their first night in the house,

Turner's oldest son was awakened by the archetypical sounds of a haunted house: moans, groans and the sounds of people walking around in the rooms adjoining his. By the time the boy persuaded his father to investigate, the noises had stopped. Mr. Turner found the situation amusing. He did not think it so droll the next night around midnight, when he was awakened by the same sounds in his own bedroom. He tried to discern whether a natural source could be causing the noises but found none. However, when he looked at the doorway he found an *un*natural source: a tall, apparently female figure clad in white. She had only one thing to say and said it with vigor: "Move!" Turner agreed with her and cleared his family out of the old Bailey house before sundown. The patriarch of the clan was heard to remark that he could not be induced to remain in the house for a hundred thousand dollars.

The word got out about the Turner family's "absquatulation," and a few brave young lads of Dunnville decided to spend the night in the house to see if anything would happen. After spending an uneventful hour in the bedroom where William Turner had seen the ghost, they were ready to go home. Then they heard an earsplitting scream, seemingly coming from under the floorboards. This was followed by a potpourri of moans, groans and cries of terror. All went silent for a moment; then the sounds recommenced with greater fury. Within moments, the brave young lads were raising clouds of dust on the road back to Dunnville.

The old Bailey house was the talk of the county the next day. Crowds of the curious searched the building for any evidence of hauntings—in broad daylight, it is understood. When investigators pried up the floorboards, they found three long holes in the dirt that obviously had been there a long time. Their resemblance to makeshift graves was convincing enough to attract the interest of the Casey County coroner, James Shelton, who summoned a jury. It was theorized that the highwaymen who had occupied the house long ago had temporarily buried victims under the floor until a permanent resting place could be found for them.

By that point, the old Bailey house was a source of nightmares for many villagers, who regarded it as being haunted to the rafters. But then William Cravens of Russell County moved into the

neighborhood. He was looking for an affordable house and the Bailey place caught his eye. He was warned about the ghost, but he said, no doubt with a magnificent sneer, that he was afraid of no "hants," and he leased the house at a bargain price.

The Cravens family slept well the first night. So concerned were the neighbors about their welfare that a party came by the next day to see whether the Cravenses had been—well, cravens, and fled in the night. Mr. Cravens reassured his well-wishers that there was no such thing as "hants," and what was more, he wouldn't be afraid of them even if they did exist. Perhaps the ghost took that as a challenge, for at midnight on the second night Cravens was awakened by the noises. Somehow, he convinced himself that they were imaginary and went back to sleep. Not for long, though. He felt an icy hand pass over his face and he opened his eyes just in time to see something white walk across the room and through the door. Mrs. Cravens whispered, "Did you see that thing? It stood by my bed and told me to move." And move the Cravenses did—the next day.

Most ghost stories would end on that note of ignominious defeat, but in this case the press account came with a signed endorsement by two prominent citizens:

> *Dunnville, Ky., April 26, 1897.—To Whom It May Concern. The undersigned, Ed Pelley, merchant, and Thomas Chelf, tavern keeper, of Dunnville, certify that they know the Bailey house, which is said to be haunted; that they know the Cravens and Turner families moved from it on account of curious disturbances at night which they could not account for, and which terrorized them; and that a party which Mr. Chelf, one of the undersigned, accompanied to the house to make inquiry into the singular things reported, became scared and left because of a recurrence of things described by Cravens and Turner. We know, further, that three graves were found beneath the floor of the old house; that Coroner Shelton investigated the case, and that the people in the neighborhood of the Bailey house are many of them afraid to pass it at night.*

The Glidewell Ghost

S.H. Glidewell was one of the most respected farmers in Bucksville, located in northeastern Logan County, almost on the Warren County border. Despite his fine reputation, for a few months in early 1887 his snug two-story log home was the most notorious house in the state, for it appeared that a ghost decided to move in without so much as a by-your-leave. It was supposed that the spirit was that of a man who had drowned years ago in a nearby creek and who was buried on the site where the house stood. A rival theory held that the ghost was a girl who had committed suicide in the house in autumn 1869, shortly before the Glidewells moved in. A third faction believed that the ghost was Solomon Rankin, a Shaker elder, who allegedly told Mr. Glidewell shortly before he died in 1882 that if it were possible for ghosts to return to earth, he would make his presence known to Glidewell. Why the ghost waited so long to get to its nefarious business, no one could speculate.

At first the unruly specter haunted only the upstairs rooms. It played the usual pranks by which ghosts announce their arrival: it artfully rearranged the furniture, moving chairs from one room to another; it yanked the covers off beds and ripped up carpets; on one occasion, it set a cheery fire in the fireplace of a room that had not been occupied in years and was securely locked. One night, as the Glidewells tried to sleep, they heard the sound of violin music and dancing coming from an upstairs room. When someone suggested fetching the neighbors, the noises stopped. When the family examined the room, they found it empty and devoid of any evidence of recent use, except for a new candle on a mantelpiece that had been burned down to a stub.

The next night, three neighbor boys volunteered to stay all night in the haunted room. Nothing happened until the stroke of midnight—of course—and then the boys were a trifle disturbed by loud laughter that seemed to be coming from a closet under the stairs. When the bravest of the three opened the door and looked in, something blew out his candle and drenched him with cold water poured from above. This antisocial deed was

accompanied by more sourceless laughter. The three young watchmen begged the Glidewells' pardon and fled into the night, leaving the family in a state of terror. The feeling only increased the next morning when the family went to the breakfast table and found it adorned with a skull and crossbones. Each plate was decorated with a small sprig of cedar, the significance of which escapes this writer.

That was enough for the Glidewells. At noon on the same day, they moved in with neighbors, going back to their house only to remove items from the lower floor—no one dared go upstairs. To their amazement, the table and chairs moved around the room seemingly on their own volition. When Glidewell's son touched a chair, he was treated to a sensation that felt like an electric shock and the sound of taunting laughter.

The house's evil reputation grew apace; soon, throngs of the curious came to see it. A Shaker village was located only a few miles from the Glidewell house and the members of that sect were so terrified that Elder Harvey Eads had his hands full persuading them not to abandon the village. Even William Guion, marshal of the town of Auburn, felt it worth his while to investigate the house (with an armed posse, let it be noted). They saw nothing suspicious, but heard many bizarre and scary sounds, including the laughter, and "unable to solve the mystery [they] returned home worn out and thoroughly convinced that there must be something supernatural about it," in the words of one newspaper correspondent, who also assured readers that his information was "gathered from conversations with some of the very best men in the county, who live in the neighborhood of Bucksville and know that the facts above related are true."

By March, newspapers across Kentucky were reporting the strange doings at the house. Mr. Glidewell's move to another home was unsuccessful, for the entity followed him and increased its intolerable behavior. It continued to open secured doors and shuffle the furniture around to suit its own peculiar notions of interior decorating. Its hideous laughter kept family members awake for hours and the ghost enjoyed tossing cold, foul-smelling water on people. It also put the stinky water in milk containers and oil lamps.

The apex of weirdness came on the night of March 30, 1887. The family was asleep when Mr. Glidewell snapped awake all at once, "conscious of a strange and unnatural presence." He became aware of a bluish light glowing through the east window from outside. It soon became bright enough to illuminate the room. Creeping to the window, Glidewell saw a pale blue flame, about three inches in diameter, levitating a few feet above his yard. The flame began to sway to and fro and Glidewell heard "faintly the sound of weird, flute-like music, played in slow and solemn measure, to which the moving flame gracefully kept time." Mr. Glidewell wanted no more and took gun in hand with the intention of blowing the ghost to atoms. But as soon as he opened the door,

he was knocked unconscious by an overpowering, strange perfume. He came to at dawn, only to find on his forehead a sopping wet red handkerchief with the initial "U" neatly embroidered in black silk on it. The ghost had refrained from playing with the furniture, for once, but Glidewell's gun had vanished. Hundreds of people came to see the handkerchief, but no one could claim to have ever seen one like it. (A contemporary report adds, "A. Lobred, a merchant in Auburn, claimed to have sold it, but when this was fully investigated it turned out that he had circulated this report merely as an advertising scheme, and that there was no truth whatever in it.")

Glidewell had borne up bravely under his supernatural persecutions until this point. The incident with the blue light so demoralized him that he slipped into depression. A reporter noted that neighbors feared for his mental health: "If he could dispose of his property he would move out of the state, but he can find no one who will take the place at any price, and as he is a man of limited means and a large family, he is perforce compelled to stay where he is."

The sheriff of Logan County declared an intention to thoroughly investigate the "Glidewell Ghost," but it does not appear that he solved the mystery. Skeptics had theories: it was hinted that the family invented the story as a pretext to abandoning the farm and not paying off the mortgage, which if true makes the Glidewell saga a nineteenth-century precursor to the *Amityville Horror* hoax of the 1970s. Another theory held that the seemingly supernatural doings had been the pranks of a Glidewell daughter, something her father denied. In April, the *Bowling Green Times* suggested that the haunting actually was the work of three daughters acting in collusion with a view to scaring their stepmother off the premises. Certainly some of the incidents sound like the work of a bold practical joker—since when do ghosts throw water at people and need to burn candles in order to see? Also, poltergeist-like activities usually turn out to be hoaxes perpetrated by attention-seeking children or teenagers, of which the Glidewell family included four. This would explain why the ghost followed the clan into new quarters. On the other hand, some of the activities, if accurately reported, sound far too

complex for a prankster to pull off. For example, I'd like to know how a joker in the days of the infancy of recorded sound could have perpetrated elaborate dancing and fiddling sounds in a closed room that was promptly investigated and found empty, to say nothing of the levitating, swaying, music-playing blue flame at the Glidewells' front door.

In mid-April, the *Owensboro Messenger and Examiner* suggested that all offered explanations had proven false: "The Glidewell ghost of Logan County, the *Russellville Dispatch* to the contrary notwithstanding, has not been discovered. The manifestations are there, but the most acute observation has failed to discover the author. Whatever the trick is, it is most ingeniously concealed." By mid-June, the ghostly deeds had stopped and the Glidewells were persecuted no longer.

A Ghost from Old Rockcastle

David Everhart holds two places in Kentucky history: one is innocuous and one unenviable. He was an early Rockcastle County settler and he also was the first man to be murdered in the newly formed county.

Everhart, a rough-and-tumble native of North Carolina, moved to Rockcastle with a party of adventurers in search of the legendary Swift silver mine. He also sought another sort of treasure: he fell in love with a beautiful but dissolute girl named Mary Wise. However, he had a rival in the form of Cyrus Thomas, a man of a similarly violent nature. Everhart and Thomas at last agreed to play a game of cards with the girl as stakes—that is, the loser was to give up pursuit of Mary Wise and leave the territory. Everhart won the game, but Thomas was a sore loser and welched on the bet by stabbing Everhart to death. The next morning, passersby found the corpse lying in the threshold of a log shanty. He was buried in an unmarked grave, never to be avenged in this world, as Cyrus Thomas fled the county.

Years later, Everhart's relatives erected a sandstone monument at his resting place. It was about three feet high and three feet wide and read: "1773. David Everhart Was Born in October; Murdered Sept. 22, 1810." Locals believed the gravesite was haunted. It was said that a mysterious ball of fire burned at the head of the grave nightly and some claimed that once a year, a shadowy figure toting a coffin walked out of a nearby orchard and disappeared once it reached Everhart's grave.

J.S. Wilson, writing in 1897, described the grave's location as being "on the edge of an old barren orchard, a half mile south of Brodhead...on the summit of a steep cliff, some thirty feet in height, which borders a seldom-traveled passway known as the Negro Creek road. A more lonely spot, with more dreary surroundings, is hard to imagine." Perhaps it is still there, still lonesome and still the focal point for strange lights and shades bearing coffins.

Bones under the Floor

There was once a house of eerie reputation on a farm about two miles east of Flemingsburg, Fleming County. Rumors swirled concerning peculiar doings in the house, which according to one contemporary news account was owned by an eccentric fellow named Augustus Sanford. (The name Augustus Sanford does not turn up in the Fleming County census records, but there is an Augustin Sanford.) A trapdoor in one room allegedly led to a hiding place under the house for Confederate soldiers. Then there was the mystery of Dr. Bradshaw, a traveling dentist and racehorse owner who had visited at the Sanford house for a while around 1879 and was neither seen nor heard from again.

After Sanford died, his house was occupied by William Black and family. One day in summer 1900, ten-year-old William Jr. claimed to have been confronted by a ghost dressed in white while he was playing in the orchard. The spirit told the boy luridly detailed stories of the murders of men, women and children and told him that if he looked under the house he would find proof.

Most parents would scoff upon hearing such news from an excited child. But Little William's parents believed him and hired workmen to cut a hole in the floor and start excavating. I do not know why they ruined the floor when they could have gone through the trapdoor. On June 9, the searchers found scraps of clothing and bones. Dr. H.C. Kehoe examined the remains the next day and declared that they were the relics of a human infant and a human adult.

Then a couple of enterprising gentlemen from Poplar Plains decided to put the young medium to the test. One of them took an old half-dollar coin and scratched the long-vanished Dr. Bradshaw's initials on it. They visited the Sanford house and got the Black family's permission to search around under the floor. After a while, the men emerged with the coin, feigning surprise and undoubtedly saying things like "Ah ha!" Little William immediately went into a trance and the "ghost" of Dr. Bradshaw affirmed that the coin had been his property while he had lived in the world. That, and the revelation that the bones weren't human after all, demolished what seemed for a short time to be a great mystery.

Reliable Wraiths

The problem with ghosts is that they are temperamental and keep their own hours. They never materialize when you wish them to; instead, they show up when they feel like it, generally when you are least expecting them and are therefore unlikely to be appreciative of their presence. A few Kentucky ghosts, however, allegedly kept regular office hours and thus scores of witnesses saw them.

One turned up at an exotic section of Garrard County: Bryantsville, seven miles northwest of Lancaster. About 125 years ago, there stood in this place a mansion, much the worse for wear and not lovely to the eye, but surrounded by majestic ivy-covered cliffs and the silent forest. Travelers on the Lexington and Lancaster

turnpike were surprised to find that someone actually lived in the dilapidated house. He was Edward Ford, a man whose reputation for honesty was unsurpassed in Garrard County, and who allegedly saw a remnant of the restless dead on his property. This is Mr. Ford's testimony:

> [W]*hile walking up a narrow, steep and road-beaten path at the rear of my dwelling, when about one hundred yards advanced, I met what I supposed to be a neighbor, but upon looking more closely I saw I was mistaken. By this time I was within ten feet of it. It stood still, and I spoke, but it made no reply. Then, for the first time, I saw that it wore a deathly pallor, and seemed not to be of flesh and blood. Somewhat nervously I returned to my house, and came back with a five-chambered revolver. It still stood where I left it, and I made ready to fire. Before doing so, however, I asked it to speak, if it were human, and if it were not, to quit my sight. It did neither, but began motioning with its hands and head for me to come nearer to it. Then I fired, and, waiting each time for the smoke to clear away, I continued to do so until I had emptied every chamber. When the smoke from the last discharge had passed off, it immediately vanished. I saw it no more during that day, although I hunted for each and every trace of it.*
>
> *Next day, however, that is on Sunday, in company with four other gentlemen, namely, Robert Boker, Thomas Lane, David Owens and Samuel Newton, I went to the same spot, and we all saw the same I had seen the day before. To the best of our judgment it seemed to be a very old man, with flowing white beard coming almost down to his waist. It began motioning as before, with hands and head, but upon the first shot being fired it disappeared. I have seen it since in various places about my house and premises, but never fail to find it at that particular spot whenever I go near it. Others have seen it, and you can ask them about it also. I do not know what it is; I don't pretend to say; but these are the facts. I believe it is a warning of some kind sent to me, and I expect to live to see the end of it, but beyond this I am at a loss as well as you.*

According to a newspaper correspondent, "more than a hundred others" had seen the ghost and all gave identical testimony. None of the witnesses would claim that what he saw actually was a ghost, but all admitted to being baffled. They were all "men of nerve, not easily deceived and determined to find out the truth if possible." News of the wraith had spread wide and inspired terror in the hearts of many, wrote the reporter. He ended his piece by stating that he intended to go see the ghost himself, accompanied by a hundred other men (which does not speak well for the writer's courage). He promised that he would send a detailed account if he or anyone else saw the ghost. Frustratingly, he appears not to have sent further reports, so we may never know what, if anything, was haunting Ed Ford's farm. The fact that Ford shot at it several times with no decisive effect suggests that it was not the work of a run-of-the-mill practical joker. Perhaps the precise location of its haunt has been lost to memory and the ghost still appears, but only before the eyes of mesmerized forest animals.

Another well-observed ghost was Jane Brown, a black resident of Henderson County who died around March 1890. She had lived in a cabin on Hart Floyd's farm near Cairo and evidently wanted to remain. Within a year after her death, she could be seen on a regular basis standing beside the cabin's fireplace with her hand on the mantelpiece. Unlike most ghosts, she appeared during daylight hours as well as at night. Literally hundreds of people came from miles around to peer at her through the cabin window—but no one was ever brave enough to go inside and confront her. It was reported that on March 2, 1891, at least five hundred people sojourned to the cabin and none went away disappointed. They agreed that Mrs. Brown looked exactly as she had in life, only thinner. In fact, she seemed so lifelike that some people believed she must have faked her own death. This theory, of course, was absurd. Why would Mrs. Brown successfully trick people into thinking she was dead and then be so foolish as to display herself daily and nightly in front of hundreds of witnesses and thus risk exposure? It's somehow easier to believe she came back from the dead.

A ghost that made customary rounds, at least for a while, was the talk of Harrodsburg, Mercer County, in September 1913. For at least two weeks it was seen taking an almost nightly stroll along the same invariable route. It would materialize near the entrance of North Lane in the Graded School neighborhood and walk slowly to Greenville Street. It would vanish into the night air at the gates of Spring Hill Cemetery. "There is hardly a person who lives in the vicinity where the ghost walks who has not seen it personally, or knows others who have," reported the *Harrodsburg Herald*. "Those who have seen it say that it attempts to communicate with

no one, but goes along looking as if reviewing some spot, loved in life, trying to impress every detail on its memory." The ghost was described as wearing a white gown, white shoes, a man's dark coat and a veil over its head.

EMBALMING IN THE OLD DAYS

The *Egyptian Book of the Dead* provides details about the ancient art of embalming, so the *Kentucky Book of the Dead* must do no less. What follows is an overview of the process as it was in the good old days when grandfather's grandfather went to funerals, marveled at the lifelike cadavers and wondered, "Hey, how did they do that?" before trudging home and having nightmares.

At first, of course, there was no embalming in Kentucky or anywhere else. Funerals were held and bodies were buried as quickly as possible after death, especially in the summertime or during outbreaks of contagious diseases. However, medical science was not always adept in those days at determining whether a person was *really* dead or merely in a coma, with occasional horrifying results described elsewhere in this book.

Embalming was slow to catch on. It became widely accepted only during the Civil War, when families who could afford it would arrange to have their dead soldier kin embalmed and shipped home for burial rather than being sent to a mass grave or a battlefield cemetery. The true genius of preserving the dead during this era was Dr. Thomas Holmes, who invented a safe and affordable embalming fluid. He charged $100 for mummifying officers and offered families of enlisted men a cut-rate fee of $25. When President Lincoln was assassinated at the

end of the war, his body was embalmed—to the point of being nearly petrified, some said—and sent on a tour of several cities, convincing thousands of mourners that pickling their loved ones was a splendid idea.

By the early 1880s, the procedure was widely accepted and practiced in America. It was common in most large Kentucky cities, but it took decades to catch on in the mountain counties and in rural areas. In small towns, the funerary trappings were likely to consist only of a wake, coins on the corpse's eyes to keep them from flipping open and discombobulating viewers and strips of cloth to bind the jaws and arms. A funeral service would be held either in the church or at the home of the deceased. For this final farewell, the body would be dressed in his or her Sunday best. Afterward, the body would be buried just as quickly as possible before it commenced returning to the elements. Usually the coffin was homemade and was placed in a wooden outer box, the precursor of the modern concrete underground vault. While there were community cemeteries, most rural folk were buried in family cemeteries located near their former homes.

For the dead fortunate enough to be embalmed, the process in those days consisted of removing the stomach's contents using an injection pump called a trocar, a device invented in 1878. Some embalming fluid entered the body by way of the mouth and nostrils, while the chest and abdomen were preserved by injecting fluid into the organs with a tube. If the body had to be displayed for an extended length of time, the veins were filled with the fluid by injecting it into the femoral or carotid artery. Funeral directors claimed that it was possible for a body to be preserved indefinitely, depending on the circumstances of its death and how much fluid was pumped into the remains.

Sometimes wax "eye caps" were placed on the optics of the dead to prevent that unpleasant sunken-in look. If the dearly departed happened to have been consumptive, the undertaker would use injected fluid or ice to fill out the features of the countenance. Should the cadaver bear an inappropriate expression such as terror, surprise or hate—or maybe if it died with a big, happy grin—the mortuary artiste would relax its facial muscles with warm embalming fluid and then massage the face into a look of sweet repose.

The secret weapon of yesterday's undertakers was ice. They used it to preserve bodies until embalming could be performed or as a means of temporarily preserving corpses for relatives who could not afford an embalming and thus had to have a quickie funeral. As already mentioned, some morticians used ice to freeze the faces of the dead in a winsome expression. The ice had to be carefully disposed of, especially if the "defunct" had passed away due to an infectious disease. On one especially repulsive occasion in 1885, some Louisville children saw discarded ice on the sidewalk and, it being a hot summer's day, they gave in to their natural instincts and ate some of it, afterward becoming sicker than they ever could have wished. It turned out to be, as the happy reader has already deduced, unwholesome ice that had been carelessly tossed out by an undertaker.

After the body was embalmed, it had to be dressed, properly coffined and its funeral services held. The trappings included a horse-drawn hearse, carriages for the mourners, gloves and badges for the pallbearers and of course the absurdly elaborate and costly mourning clothes of the period. Caskets in the late 1880s cost between $75 and $500 and an average funeral cost anywhere from $250 to $350—in a major metropolis such as New York City, that

TERROR SURPRISE HATE HAPPINESS

is. In 1891, a Louisville undertaker, E.C. Pearson, estimated that an average local funeral cost between $100 and $200. A dirt-cheap, no-frills, the-neighbors-will-laugh-at-you burial could cost as little as $30, including a $12 casket. Undoubtedly, funerals were even cheaper in the state's small towns.

Just for the historical record, the first female embalmer and funeral director in Kentucky was Mrs. E.H. Wyatt of Louisville, who hung out her shingle in August 1895. She won raves from the medical establishment for her mastery of the "hypodermic embalming method," which was exactly what it sounds like.

A GHOST'S DISGUSTING GIFTS AND OTHER LOUISVILLE HAUNTINGS

A Ghost's Disgusting Gifts

Annie Coleman, a black resident of Louisville, was agitated on the morning of February 14, 1885. She had received a package and though it was not exactly a Valentine's Day gift, she was in a mood to show it off. First she went to Lucien Alexander's drugstore, where she threw the package on the counter and asked the clerk to look at it; I imagine she did it with an air of "tell me if this is what I think it is." The clerk peered into the small box and saw a severed African American thumb. Her suspicions confirmed, Mrs. Coleman triumphantly took her gift to the office of Dr. Payton for a second opinion. Then she carried it elsewhere for still further confirmation.

Although Mrs. Coleman had found the box in an alley beside her house, she was convinced that a ghost had given her the thumb, for eight persons had died in the previous year in the house she and her husband shared on Congress Street, between Eighth and Ninth Streets. (Much to my sorrow, the local press did not explain how this extraordinary circumstance came to pass.) The spirits, she believed, were determined to drive the Colemans from their home and thus had been performing obnoxious stunts for the past couple of weeks, of which the amputated thumb was only the latest example.

The first manifestation of the ghosts' wrath had occurred on January 30, when Mrs. Coleman found a wee package daintily wrapped in silk in her alley. It contained neither candy nor jewelry, but two fingers that had been removed from some anonymous white person who, I hope, did not mind. Neighbors advised her to bury the remains. She did, but the ghastly "gifts" kept on coming. Soon Mrs. Coleman was finding body parts on nearly a daily basis. The gruesome offerings included fingers, toes, ears and even the occasional nose. The family respectfully buried all of the pieces—whether in the hallowed ground of a cemetery or under the carrots in the vegetable garden, accounts do not specify.

Soon the Colemans heard mysterious sounds originating from closets and from behind closed doors. At last a ghost was sighted. A guest named Mariah Brent was ironing one day when she saw a spectral figure that she could only describe as "big and white" bending over her. People even saw ghosts outside and during daylight hours; neighbors reported seeing smoky, ghostly figures floating about the house's windows.

Skeptics can write off the ghostly visions as being delusions or illusions, but what are we to make of the dismembered body parts that proliferated at the Coleman residence like plastic pink flamingos or garden gnomes? The obvious solution is to blame the pranks on medical students with an unhealthy sense of humor. But even if that were the case, the record does not state why they would be singling out the Colemans for such grotesque comedy.

Mr. Basley Returns

As the Colemans were receiving their unwanted attentions, a nearby house also was gaining a reputation for being haunted. It was an ordinary-looking double-frame tenement house located near a tobacco factory and furniture shop on York Street, between Eighth and Ninth Streets. Circa 1882, it had been occupied by an immigrant family named Basley. The patriarch was an industrious furniture maker. The neighbors liked him and became concerned when his

health suddenly failed and he seemed troubled and preoccupied. He told one of his neighbors that he expected to die soon. Less than a month later, Basley was dead. He had taken out an insurance policy for $2,000 and willed his life savings to his widow and six children, who moved to Missouri.

While Mr. Basley might have been a good neighbor in life, he was not so in death. A new family, the Browns, rented the dead man's house and moved back out with haste. They would not say much on the subject, but intimated that the place was haunted. A third family moved in and abandoned the house before long. They were more talkative than the Browns and let the neighborhood know that they had been tormented by odd lights, doors that opened and closed by themselves despite being locked and frightening sounds at all hours of the night, including what sounded like a robe being dragged across the floor. The ghost of Mr. Basley was sighted, "looking weird and ghastly in the faint gleam of light which seemed to emanate from his form."

Most locals avoided the house, but a couple of young men who worked in the nearby tobacco factory were determined to test their mettle, or the ghost's, by spending the night there. They were out by midnight, telling all who would listen that they had heard unearthly voices and thought they had glimpsed several representatives of the restless dead. "Since then," wrote a reporter who checked out the place, "no one has had the courage to repeat their experiment, and the house has remained untenanted."

The Invisible Stroller

For some reason, haunted houses seemed to be located on streets that intersected with Ninth Street. A third was found at the northwest corner of Ninth and Chestnut. It was reported to be vacant with no hope of being occupied. The ghosts in this house appear to have been a fairly pedestrian sort, doing nothing more exciting than rattling chains, slamming doors, groaning and

screaming and moving furniture. However, the manifestations were effective enough to scare off two young men, Charles Zork and Fred Heimen, who tried to stay overnight in the house on December 10, 1886. They reported hearing footsteps in an upper-floor room, coming downstairs and then exiting the front door, which some invisible hand opened and closed. After sitting in terrified silence for a few minutes, Zork and Heimen heard the process in reverse: the ghost entered at the front door and went back upstairs, where it found nothing better to do than to move furniture and scream. It was at that point that the young men remembered that they had previous engagements and left the house more quickly than they arrived.

Why Alonzo Thomas Went to Work Early

At dawn on May 26, 1889, two Louisville policemen found Alonzo Thomas standing in front of his place of employment, John Frerman's grocery store, unable to speak and wearing his nightclothes. It was evident to even the most uncreative policeman that something had scared Thomas so badly that he had abandoned his residence and fled without even changing his clothes. When he was finally able to speak, Thomas said that he had been visited in his room on East Street the night before by a saloonkeeper named Louis Roder. There was nothing intrinsically wrong with this, except that Roder had perished in the same room six months before. Thomas insisted he could not have mistaken the identification, for he had known Roder well. Others in the neighborhood had warned Thomas that the deceased barkeep kept returning to his room, but Thomas did not believe in ghosts and rented the place anyway. On the night in question, he had been awakened by a sound that he likened to a crowd of people walking up the outside stairs. When Thomas got up to investigate, he saw nobody outside his door, but in a dark corner of the room stood Roder. Unwilling to spend valuable time in the company of a ghost but having nowhere else to go, Thomas headed for the

grocery and waited there for several hours until the police found him. The reason why Roder was so attached to his apartment does not appear.

The Alford Place

On Twenty-Sixth Street, near Duncan, stood "the Alford place," a ten-room, two-story brick house built in the 1830s by W.D. Alford, who held the title of surveyor for the port of Louisville. The building had more than its share of character. For one thing, in its backyard was St. Mary's (now St. John's) Cemetery, an abandoned Roman Catholic burying ground. For another, after the Alfords left the house, professional body snatchers used it as headquarters and a temporary storage facility for their unseemly wares. Farfetched local legend held that at night ghosts from the cemetery would congregate in the empty house and hold high revel, complete with music and the dancing of the Virginia Reel. Some people in the neighborhood claimed that they had seen blue lights flickering in the windows as the spirits of the dead partied down. A thorough investigation by some brave citizens proved that the terrifying noises and eerie lights that issued from the house were real, all right—but they were made by the gang of resurrectionists, who, like villains in a Scooby-Doo cartoon, were trying to scare people away from the house so they could use it for their own nefarious ends. And they'd have gotten away with it, too, if it weren't for those meddling neighbors.

Nevertheless, the house maintained a reputation for evil that encouraged many a pedestrian to make a detour. Neighborhood children were so sure that big ugly monsters lived in the basement that they walked a circuitous route to school. They were probably the best-behaved kids in town, for youngsters living within a four-block radius of the house were too scared to stay out late at night. It was noted in one newspaper article that the house had been tenantless since around 1880; the last hardy soul who had lived there was a man named Ziegler, who moved out abruptly and

swore that he wouldn't live there again for $1,000 in cash and free rent.

In January 1898, the neighbors filed a complaint with Building Inspector Tilford in hopes that the house would be condemned, torn down and carried away, haunted brick by haunted brick. Tilford had no authority in the matter and recommended that they refer to Chief of Police Haager, who in turn informed concerned parents, "I can not keep the ghosts away either. Now, if I was called upon to keep thieves away it would be an entirely different matter. But when it comes to ghosts—I confess I am lost."

Haager was not the only policeman who expressed slightly tongue-in-cheek misgivings about the Alford place. Captain Kremer remarked:

> *If it wasn't haunted, it must have been a live person I saw dressed in white there one night. I was walking in Twenty-Sixth Street, about 3 o'clock one morning, when I heard peculiar noises in the house. I had often heard of the ghosts who held nightly meetings in the cellar. I gathered my nerves together and started in the front door. I saw a white object flitting through one of the rear rooms. I blew my whistle for a fellow officer and we searched the entire house. Then it was regarded as great sport for young men to wrap themselves in white sheets and stalk about the place, giving utterances to all kinds of moans and yells, and it might have been such a joke. I don't believe in ghosts, but you know that experience made me feel rather strange.*

The house was at last razed in the autumn of 1898. On the morning of September 15, workers found a child's skeleton under the front stoop. Most of the bones had long since crumbled to dust.

Mrs. Dewberry Finds a Treasure

John Dewberry, proprietor of a saloon at 312 Sixth Street, lay on his deathbed in June 1886. He tried to tell his wife something

but was unable to do so before passing on to the Great Groggery in the Sky. He left her with a considerable amount of money and she made even more by selling the bar to Pat Grimes and Tom Streubel. She moved to 927 Tenth Street. But despite this change of scenery, she confided to her friends that she was troubled by her husband's ghost, which often appeared before her. Desperate for peace of mind, in November Mrs. Dewberry visited some relatives named Shepherd in Bullitt County. However, her husband's ghost appeared there on the night of November 8 and beseeched her

to return to Louisville, explaining that an important discovery awaited her: he had buried money in the lot behind his bar. He gave her directions to the hiding place and told her there was more buried in the saloon's cellar.

The next morning, Mrs. Dewberry went back to her husband's bar and asked the new proprietors if she might be permitted to dig around in the back lot. They graciously agreed and observed her activities through the back window. Their amusement turned to amazement when, after clearing away some accumulated trash and digging a little, she produced a rusty sheet of tin. Underneath was a moldy table salt bag. The excited widow brought the bag into the saloon and asked barkeeper Ed Cook to open it. Then she fainted, perhaps a little too melodramatically for a skeptic's comfort. When she revived, Mrs. Dewberry asked if the bag contained gold. It did—twelve $20 gold coins, $240 in all.

Did the rich get richer with a little help from the spirit world? Dubious souls suggested that Mrs. Dewberry knew all along about the hidden money and used the story of the ghost as a clever way to retrieve it from what was then someone else's property. When she retold the story at the *Courier-Journal* office, she said little of ghosts and claimed instead that she had learned about the treasure in a series of dreams. She stoutly denied having any foreknowledge of the loot. But the ghost, if any, was wrong about there being money hidden in the saloon's cellar. Several people prodded the earthen floor with sharp sticks and raised nothing more than melancholy clouds of dust.

A Shy Ghost in Blue

Some ghosts make regular rounds in their old haunts for months, years, even centuries. Louisville attorney Alex P. Humphrey had a ghost haunt his house at 920 Third Avenue for one day only—but it was a mighty interesting day.

One morning in June 1902, Mrs. Humphrey awoke to see a pale girl with blue eyes and blonde hair standing next to her bed.

The girl's out-of-style blue dress seemed somehow familiar to Mrs. Humphrey, though her face did not. When the lawyer's wife sat up, the girl disappeared. Mrs. Humphrey said nothing of the apparition to her family, thinking it a dream. But that evening, as the family sat on the front porch, the girl in blue entered the maid's third-floor room. The maid, assuming the stranger was a visitor who had lost her way, said, "All the family are on the front porch." The girl in blue said nothing but bowed and left the room, closing the door as she exited.

Minutes later, a guest named Eppie Prather nearly ran into the strange girl in the second-floor hallway at the top of the stairs. Miss Prather thought the girl seemed confused and asked if she were looking for Mr. Humphrey's daughter, Mary Churchill. The girl silently nodded and smiled. "She is down on the front porch," said Miss Prather. The girl in blue bowed, smiled again and went downstairs. At that point she vanished, seemingly forever. No one saw her leave the house and it appears no one ever saw her again.

The mystery deepened a few days later when the family commenced packing for a trip to the country. While doing so, Mrs. Humphrey chanced to look into some old, long-unopened trunks. At the bottom of one, she found an antiquated blue dress. She, Miss Prather and the maid all recognized it as the same garment worn by the silent, shy ghost.

The Courthouse Ghost

A couple of weeks before Christmas 1902, the night employees at the Jefferson County Courthouse reported seeing a ghost of frightful appearance in the building. The most detailed story came from Fred Hatzell, whose job it was to keep the furnace stoked. One night at work, he thought about Charlie Gebhard, a forty-eight-year-old courthouse custodian whose years of toil had come to a permanent end on November 12. Hatzell looked over his shoulder and made eye contact with a "semi-solid

human form" with gaseous flesh, through which he could see the figure's skeleton. It had a bare skull atop its shoulders rather than a fleshy face.

Whatever it was, it was on a first-name basis with Hatzell and was in a sociable humor. "Hello, Fred," it hissed. Hatzell did not stick around to reminisce about the old days or to gossip about the boss,

but went to see if anything interesting was going on outside. Within moments, his sense of duty overcame him and he reentered the furnace room. Much to his relief, the skull-topped thing was gone. Whether it was ever seen again, I cannot say.

A MORBID MISCELLANY

A Premature Burial Nearly Averted and an Invidious Message

The *Lexington Statesman* reported a bizarre but improbable event that took place at the funeral of a child in 1869. Allegedly, after the funeral services, a man who intended to lower the small coffin into the empty grave found it too heavy to lift. Puzzled, he called a man over for assistance and the two straining together could not pick up the coffin. This rare spectacle attracted attention and within moments four men were trying and failing to lift the child's coffin. They decided to peek inside to see what the matter could be—and found that the "dead" child was actually alive. The general belief was that the Almighty had performed a miracle to spare the child from the horrible fate of premature burial. Further inspection revealed a strange message written on the bottom of the child's feet: "There Has Been No Preacher in Heaven for Eleven Hundred Years." The *Statesman* remarked, "It is our opinion that some designing scamp has been playing upon the credulity of these people for sinister purposes." Indubitably—but what could those "sinister purposes" possibly have been?

A Tragic Tale Briefly Told

Jane Stull (or Hull) of Owingsville, Bath County, was to be married on October 29, 1888, but died of a fever that day. By her request she was buried wearing her engagement ring and dressed in her bridal gown.

Getting the Finger

Charles Clay of Henderson, Henderson County, was a gambler who consistently lost at cards. One day in September 1891, some of Clay's cronies told him of a superstition that held that the severed right forefinger of a dead woman is a powerful good luck charm. Clay tried to turn his life around by exhuming the grave of Mrs. James Henderson and removing the recommended digit. Somehow, the unamused widower found out about it and had Clay arrested. The record does not state whether Clay's luck improved, but perhaps the court found occasion to be lenient with him on the grounds that he had left behind a valuable ring on Mrs. Henderson's left hand, proving that his motive had been stupidity, not robbery.

You Can't Keep a Good Man Down

When the dead are buried, they are ideally supposed to stay put. That isn't always the case, however. Often in bygone days, grave robbers dug up bodies—as happened to the remains of William Shanklin, a farmer from Beechburg, Fleming County, who died on August 30, 1897. Three days after his burial, somebody unearthed his body in order to make off with his lungs, heart and other organs for reasons known only to God. On other occasions, bodies were exhumed for legal reasons or to be moved to another resting place—or just because the next of kin got curious and wanted to sneak a peek.

Take, for instance, Samuel Stone of Hurricane, Crittenden County, who lost two of his children within a fortnight in April 1896. Having decided that he wanted a photograph taken of them, he had the children's bodies exhumed. He hauled the two little coffins on a wagon to a studio in Sheridan, where he had each child photographed. Then he had the coffins reburied in Hurricane Cemetery.

In February 1881, the daughter of James Braddon of Pulaski County married a man named John Hinds. Only a week later, he died of consumption. The young bride's mind snapped and one night in early March she was found in the cemetery holding the disinterred body of her late husband. She explained to onlookers that she thought she could bring him back to life.

A similar incident came to light on the morning of February 1, 1911, when the sealed coffin of attorney George Saufley was found lying atop his Lincoln County grave. Police soon had Amanda I. Harrison in custody. She admitted to having exhumed Saufley, who had once represented her in a divorce case, explaining that God had told her in a vision that the lawyer would come back to life if his body were exposed to the air. She had managed singlehandedly to dig up his casket, but had to abandon her plan when dawn came and she feared being seen. The press did not report what happened next, but it is probable that Miss Harrison was taken to a nice, quiet place for a long rest.

In January 1887, a woman who had been widowed for years visited her husband's grave at Mount Olive Cemetery in Mason County. When she noticed the dirt was disturbed, she feared his body had been stolen. After much beseeching, the sexton at last agreed to grab a spade and satisfy her curiosity. When the lid was opened, she saw that her husband was still there and with seemingly petrified facial features. "She can not account for her desire to have the grave opened," remarked a contemporary news account, "and says she wouldn't have it done again for all the world."

Fear of grave robbery led the parents of Scott Harrison of Jessamine County to extreme measures when he died in April 1896. A press report explained, "His parents, believing his body would

be stolen, had the grave opened and are secretly watching it." Of course, the fact the newspapers described their plan kind of spoiled the secret.

The wife of Anijah Humphries of Crocus Creek, Adair County, was buried in the local cemetery after she died in 1898. The fact that he was separated from his wife preyed on the old man's mind night and day until he had a happy idea. Just before Christmas, neighbors saw him building a vault near his house. When the work was completed, Mr. Humphries hitched his horse to a sled and drove to the graveyard. Without considering the social proprieties of his actions, and despite the vehement objections of his children, he exhumed his wife's casket and dragged it home. He placed the casket in the homemade vault where, like the protagonist in Edgar Allan Poe's poem "Annabel Lee," he frequently opened the casket and whiled away dull care by looking at his wife's remains. In February 1899, the *Columbia News* remarked, "Mr. Humphries was in Columbia a short time ago and he informed Mr. J.O. Russell, a prominent merchant of this place, that his departed wife looked perfectly natural and that there was no odor whatever about the vault. He said that it was a great comfort for him to sit for hours and gaze upon the face of the one who in life rejoiced in his prosperity and who weeped when adversity came." Mr. Humphries died by the side of the road in October 1905, when he was ninety-five years old.

As the Humphries case suggests, sometimes bodies whose eternal slumber was disturbed were in surprisingly good condition. This never failed to generate intense amazement, especially if the body had not been embalmed. When the body of Abraham Wilson was exhumed from the family burying ground in 1878 in order to be moved to Danville Cemetery in Boyle County, it was noted that even though he had been dead for seventeen years, "[h]is appearance and clothing were as fresh as on the day of burial," marveled the *Danville Local*.

The body of one Mrs. Young, who had died of cholera in 1854, was removed from its grave in Paris, Kentucky, in 1872 and taken to Mount Sterling for reburial. When her daughters peered through the glass faceplate in the coffin lid, they were amazed to find that she was

in near mint condition, right down to the bouquet on her chest and the rosebuds in her hair.

John Wilson of Louisville had a three-year-old son, Harry, who died in November 1868. He was buried in a cemetery east of the city and slept in peace until around 1884, when he was exhumed and taken to Falls Cemetery for burial in the family plot. The boy's kin wanted to take a peek at him and found to their surprise that he looked perfect, even retaining his curly blonde hair. In 1895, the Wilsons decided to build a monument on their plot, but in order to do so little Harry had to be exhumed and moved a second time, as he was buried on the spot where the monument was to stand. Naturally, everyone wondered if he would still look as natural as he had when last they saw him in 1884. They found that he looked as spruce as ever, with one difference: at some point his hair had grown to over a foot long.

In October 1892, eight bodies were removed from a farm five miles from Louisville on the Shelbyville pike to be reburied in the city's Eastern Cemetery. One small metallic coffin contained the body of a child named Archie Cocke, who was so well preserved that he looked as if he had just gone to sleep, though he had died at least a half-century before. A fresh-looking yellow rose was still pinned to his shroud.

When undertaker Al Smith dug up the body of John Stafford in Louisville's Pennsylvania Run Cemetery on April 30, 1897, he found that the wooden coffin and Mr. Stafford's clothes had crumbled to dust—he having been buried for forty-six years—but the body itself was in perfect shape, though "white as Parian marble." Mrs. Stafford was also found to be in the same peculiar condition. Local scientists and doctors expressed interest in the strange case.

William Evans, a Daviess County settler, and his daughter Josie were buried in a family cemetery but were removed in 1890 to Elmwood Cemetery, Owensboro. W.W. Harris of Habit wrote to the *Owensboro Messenger and Examiner* on the occasion:

> *He had been buried twenty-seven years, but was found to be petrified. Every feature was almost perfect with a gloss over them like china. I was deeply impressed as I beheld for the first time*

since babyhood the face of dear old grandpa. [Josie] had been in her grave twenty-one years and when taken up looked like wax. Every feature was there. A wreath of flowers was still round her head. A white silk bow and a small gold pin rested on her bosom. She looked as if she was in peaceful slumber.

Several preserved bodies were found when the corpses in Lexington's Presbyterian Cemetery were removed and taken to other graveyards in summer 1889. In fact, for the next six years the papers reported on discoveries made there. In one instance, the body of a woman buried in 1857 had disintegrated into a pile of bones, ashes and hair—but her expensive silk dress was in perfect condition. Another anonymous body in an iron coffin was dubbed "the bride" since she had been buried in a bridal gown, her "form still retaining all of its naturalness and beauty." Not even the oldest inhabitants knew who she was, and her identity and tragic story remain unknown. At the end of April 1890, two metal caskets were unearthed, each containing a preserved body. One was Corinne Sylvester, who had died in 1858; she had so well fought off the ravages of deterioration that onlookers saw that her dress was a slate-colored muslin with dark velvet trimmings. The other body was that of a Union soldier in uniform, complete with medals. He was in flawless shape except for his sunken eyes and was thought to be Jonathan Cannon of Winchester, Clark County. As late as August 1895, workmen found the metallic coffin of a perfectly preserved ten-year-old girl who probably had been underground about sixty years.

The reader will notice that in many of these cases the corpses had been buried in metal caskets, which slow or prevent decay. Impressive as these incidents were to our ancestors, even more spectacular were cases in which the bodies were not just perfectly preserved, but seemed actually to be petrified. Kentucky-born skeptic Joe Nickell has noted that most of these "petrifications" actually were adipocere—a waxy substance that forms on the fatty tissues of buried bodies due to moisture. Another theory mentioned in the *Louisville Courier-Journal* in 1886 holds that corpses in limestone country "petrify" when lime-rich water seeps into caskets and

forms a hard crust around a body. For example, the occupants of the Buena Vista Cemetery—which happened to be on limestone—were moved to the Mother-of-God Cemetery near Latonia, Kenton County, in October 1895. A man named Rowekamp was found to be perfectly preserved, but with a petrified body. Similarly, in July 1822 a woman dead eleven years was unearthed in Bourbon County. Her exhumers were astounded to find her body intact and solid as a rock, though the coffin had disintegrated. An old account tellingly notes that the corpse's "specific gravity was about the same as that of common limestone." According to the same account, "Her countenance had undergone so small an alteration that her husband, it is said, on beholding her, fainted." In 1900, the Peak brothers of Trimble County had their brother Tom, sister Martha and mother exhumed from the family farm and moved to a cemetery. Brother and sister had been buried for twenty-seven years and fifteen years, respectively, and were in deplorable shape. But the matriarch had been buried for seventeen years in a leaky metal casket that allowed water seepage. As a result, her face was perfectly preserved "with the appearance of a statue." Even her hair resembled that painted on a china doll.

In a 1999 issue of the *Skeptical Inquirer*, Joe Nickell mentions the case of a "petrified girl" that has assumed legendary status in the vicinity of Ezel, Morgan County. Nickell's research determined that the girl in question was Nancy A. Wheeler, who died at age

seventeen on October 1, 1885, and that the exhumation most likely occurred in late February 1888. Legend holds that Wheeler's casket was filled with water when taken up out of the ground, so we may safely attribute her remarkable preservation to natural—albeit gruesome—means, such as limestone minerals or her tissue turning into adipocere.

The most horrifying discovery that could come from opening a grave was that the occupant had been buried alive, a not infrequent occurrence in those wonderful days gone by. Once the practice of embalming gained acceptance, people realized that it had a side benefit: not only could the dead be preserved, but also it made premature burial an impossibility. Individuals who took ill in pre-embalming days had good reason to worry—and in latter days, too, if their relatives were too poor or too cheap to spring for the procedure. In November 1875, for example, the *Scottsville [Allen County] Argus* reported that a mercifully unnamed woman who had been buried a short distance from town was exhumed so the body could be moved to another cemetery. When the coffin was opened, gravediggers found the woman lying on her left side and "bearing unmistakable evidences of a struggle to obtain freedom." An editorial in the *Courier-Journal* of November 9 halfheartedly attempted to persuade readers that the *Argus* had perhaps jumped to conclusions, that authentic premature burials were "rare" and that, just maybe, "chemical or mechanical" causes had turned the woman's corpse on its side.

Another unfortunate was H.T. Huddleston of Rileys Station, Marion County, who was buried on July 3, 1894. It was noticed that his body perspired constantly even after his "death," and after he had been interred his relatives grew apprehensive that they had buried him before his time. They had the coffin exhumed and when the lid was opened they found that Huddleston was indeed dead. But his face bore a distorted grimace that had not been present at the time of burial.

Contemplate the case of George Stutt, a twenty-five-year-old Kentucky saloon proprietor who seemed to have died of pneumonia on January 8, 1888. He was buried the next day. Nothing seemed amiss until June, when Stutt's family arranged

to have him exhumed and moved to the family plot in Calvary Cemetery, Louisville. His sisters and friends insisted on opening the coffin in order to see Stutt's face one last time and soon wished they hadn't. The glass under the lid had been shattered, leaving shards inside the coffin. Stutt was lying face down with his arms drawn up under his chest. When he was turned over, they found that his face had been lacerated by the broken glass. The undertaker who had had charge of the body swore that he had embalmed Stutt with an arsenic solution, which would have killed him had he not already been dead. He theorized that if the coffin had been roughly handled when being consigned to the earth, it would explain the broken glass and shifted body within. Stutt's family didn't buy it, pointing out that there would be little room in a coffin for a body to accidentally turn over, that cuts indicated that he had been face-up when the glass broke and that his arms were in a drawn position.

I have uncovered (sorry) dozens of genuine instances of premature burial while doing research on other, more wholesome matters, but found few that happened in Kentucky. However, I did find reports of people who came very close to meeting the most horrifying of conceivable fates. On January 20, 1887, a physician pronounced the one-year-old daughter of Louisville stonecutter Wilhelm Sperinfogle dead. The next day, as the parents rode to St. Louis Cemetery in a carriage, they heard disconcerting sounds emanating from the tiny casket. The driver broke the lid open with his whip handle, and the Sperinfogles found their child still alive. They hurried home and called in the doctor, but by the time he arrived the girl had died for certain. She was buried on January 22, no doubt to her parents' trepidation. Luckier was the child of Lee Gamble of Laytonsville, Christian County, who seemed to have died of typhoid on or around December 15, 1900. The child was actually prepared for burial and was just about to be lowered into the cold, cold ground when a doctor noticed signs of life.

The Bath County funeral director who was preparing the body of Mrs. Maguire Sanders for burial in May 1889 was surprised to find that she was still alive. "The funeral was postponed," a newspaper account noted with admirable dryness and understatement.

Another disturbing example occurred in June 1890 in the Four-Mile neighborhood in Kenton County. Mrs. Jacob Korb, who had been suffering from a long illness, died on a Monday. Her funeral was held in the neighborhood church on Wednesday, after which her casket was borne to the empty grave in the churchyard. But en route, a loud groan issued from the casket, causing the panicked pallbearers to drop it. When the lid was opened, Mrs. Korb lay within, eyes wide open. When she sat up, witnesses fled, fainted, screamed or stood helpless in terror. The husband, who had thought himself a widower, pulled her out of the casket and carried her to the church. There she looked around in fear, unable to speak. She got to her feet as if to run away, but then collapsed. A doctor showed up and declared her authentically dead—presumably from her long-standing illness, though the horror of waking up in a casket probably didn't do her any good. Her body was replaced in the casket and buried. A contemporary account noted, "People in that portion of the country are said to be much excited, and many do not believe Mrs. Korb should have been buried."

Tyree Ratcliff of Carter County, "one of Denton's oldest and most highly respected citizens," died of heart failure on May 3, 1903, but woke up as relatives prepared his funeral. They had gone so far as to dig his grave and had Ratcliff not revived when he did, he certainly would have been buried alive. One wonders how many cases of premature burial were never discovered.

An Unanticipated Detonation

The friends and relatives of Trigg County's L.P. Dunn got a most unpleasant surprise when they attended his funeral in March 1895. Little did they know that dangerous amounts of gas had accumulated in the body's entrails. They found it out when the coffin was being lowered into the grave and the corpse exploded with such force that the lid flew off and shattered glass from its window sent the mourners packing. After a while, a few cautious men returned to the gravesite and, "though shrinking away from

the loathsome sight revealed," they repaired the coffin as best they could and put pieces and scraps of Mr. Dunn back in. The services continued as before, though I would wager the mourners kept their umbrellas at the ready.

Crowded Quarters

George Fahey, assistant sexton at Louisville's St. Louis Cemetery, was suspicious. Was it truly necessary for Mr. Anthony Philburn's casket to be sealed with eight nails in addition to the usual four screws? Mayhap I had best investigate, Fahey said to himself. When he opened the lid, he beheld not the expected Mr. Philburn but a nearly naked headless woman and eight deceased babies. That satisfied his curiosity. An investigation held later in the day, December 4, 1889, revealed that it was all just a wacky mix-up: the nine bodies had come from a medical students' dissecting room at the University of Louisville and somehow their coffin had been mixed up with Mr. Philburn's.

Resting, But Not in Peace

John Cronin, deputy marshal of Montgomery County, committed suicide via morphine on April 1, 1882. His family owned a plot in a Mount Sterling Catholic cemetery, but the church refused to allow his burial in consecrated ground. He was buried instead in the potter's field section of a Catholic cemetery in Paris, Bourbon County, on April 3. The church's decision did not sit well with some of Cronin's relatives in Cynthiana and on the night of April 7, they displayed their loyalty by digging him up, without the properly signed legal paperwork I assume, and reburying him in the family plot back in Mount Sterling.

The church retaliated a couple of days later by hiring four men to exhume the body with the purpose of returning it to the lot

in Paris. The proceedings were witnessed by James Cronin, the dead man's outraged brother, who offered to whip every man in the crowd. On the night of April 14, Cronin's well-traveled remains were removed from Paris yet again. This time, as a sort of compromise, he was taken to the Mount Sterling city cemetery rather than the Catholic burying ground. As far as can be told, he is there yet.

A Unique Casket

In April 1896, workmen digging up part of a cemetery in Henderson unearthed a strange metal casket that was shaped like a human body and fit its tenant "almost as tightly as a winding sheet." When the faceplate was removed, the workmen stared into the well-preserved face of a woman. Nobody in the area had any idea who she was, but some theorized that the unique casket had come from Europe. (My guess is that the laborers uncovered a Fisk casket, an airtight, form-fitting metal coffin manufactured in the 1840s and 1850s, which closely resembled the description provided in the press accounts. A handsome, unoccupied example is on display at the Museum of Appalachia in Norris, Tennessee.)

Disgraceful Cemeteries

Richmond Cemetery in Madison County is a beautiful and well-kept burying ground today, but it was not always so. In the 1880s, the cemetery badly needed a stone fence erected along the Main Street side to prevent human bodies from sliding out onto the streets due to soil erosion. An editorial in the *Richmond Register* of April 7, 1882, graphically explained the problem: "It may be that the relatives and friends of these departed ones have all disappeared; still it would be better not to have human bones scattered about the streets. A small boy making a foot-ball

of a human skull is not precisely the correct thing. The sight of a playful pup wagging off a leg bone of some old pioneer of the town is not a beautiful or pleasing sight." Obviously, the town fathers did not consider it a pressing matter, for a stranger complained about the graveyard's scandalous condition four years later in a letter to the *Register*.

This was not an uncommon state of affairs in many Kentucky communities at the time. In 1887, a *Courier-Journal* correspondent literally stumbled over a human skull in a Henderson cemetery; in July 1897, a grand jury issued an indictment against the city of Lexington due to the sad state of its potter's field, where "hogs... fatten there on carrion."

Peculiar Wills

J.A.J. Mickel was a prominent but eccentric farmer who lived near Monticello, Wayne County. After doing intensive study of the Bible, Mickel came to the conclusion that he would be translated into heaven, like the prophets Enoch and Elijah, on November 13, 1878. Friends and relatives laughed at Mickel's notion, but that did not stop him from writing his will a few days before the anticipated event, in which he vowed that if his wife were translated as well, he would give to God all of his material possessions except money owed to him by debtors:

> *Now, in accordance with the dictates of my conscience as a sane man, this day being the ninth day of November, 1878, I do make and draw with my own hand this my last will and testament, in accordance to the circumstances hereinafter mentioned, to-wit: First—If, according to the calculations from the Bible, the day of translation occurs on the 13th of the present month, my will is that all of my possessions be bequeathed to my wife, for her support, provided that I am found worthy to be translated without her. But if we are both found worthy and pass away and leave all, I then bequeath all my possessions to Him who*

gave them to me, excepting all the dues from all people to me of every descriptions, such as notes, accounts, loans, or anything in their hands belonging to me, which I freely forgive them for Christ's sake. Given under my hand and seal on the date above-mentioned. J.A.J. MICKEL (Seal.)

When November 13 came, the weather was so gloomy and strange that some people thought Mickel was going to be lifted bodily to heaven after all. He wasn't, though, and fifteen years after his disappointment he decided to change his will.

This is my first codicil: As my wife is the only other person interested in this matter [emphasis added], I will that she, being fully acquainted with my affairs, be appointed executrix of my estate, manage it herself with aid of the witnesses hereto for her support through life. Written

with my own hand, but not quite so steady as formerly, August 21, 1893.

Mickel may be the only person in history to have cut the deity out of his will. He died around 1894. His bizarre last will and testament may still be on file in some moldering courthouse volume.

Another admirably strange will was a thirteen-page opus by the well-to-do Mr. Southern Kalfus of Louisville, who died in early October 1897. After rambling for a while about various tests he wanted performed on his corpse to ensure that he would not be buried alive, including having his toes burned with a candle, Kalfus requested that his money be used to build an "Incurables' Resthaven," a place where terminally ill patients could "rest...for a season while on their way to heaven." The place was to be built on the outskirts of the city, "outside the smoke cloud that hovers over Louisville constantly, and beyond its tax limits." The inmates were not to drink water from creeks, springs, wells or rivers (what *were* they to drink?); no one would be permitted to play cards or smoke tobacco on the premises; nor were they to eat the flesh of the hog, eel or rabbit. Mr. Kalfus appears to have held a grudge against traveling salesmen and members of secret societies such as the Masons, for no one from either group was to be admitted to his proposed Utopia. Not surprisingly, the court threw the will out in the belief that Mr. Kalfus had been mentally incompetent when he wrote the document.

After Virginia Smith Kelly died in Louisville in mid-December 1901, the relatives of her late husband, Joseph Clay Kelly, found out what she really thought about them. She added a provision teeming with scarcely concealed bitterness: "To those of my husband's family who took from me the extra $10,000 that he told me he had left me, I bequeath this amount in order that they may have a perfectly clear title to it, and I would earnestly request that they would read Exodus 22 ch., 22, 23, and 24 verses."

The verses Mrs. Kelly referred to promised divine vengeance: "Ye shalt not afflict any widow or fatherless child. If thou afflict them in any wise and they cry at all unto me, I will surely hear their

cry. And my wrath shall wax hot and I will kill you with the sword and your wives shall be widows and your children fatherless."

He Came to Bury, Not to Praise

One day in mid-August 1897, Thomas Giles of Newport, Campbell County, stepped off the rear platform of a Richmond-bound train. Why he did that nobody knows, but he probably miscalculated the locomotive's speed. He was killed instantly when his head lit on a railroad tie. A sensation ensued when it came out that the woman who had been accompanying Giles on the train, and whom he had introduced as his wife, was actually a mistress.

Usually the minister officiating at a funeral will be a good sport and offer words of praise for the deceased, deserved or not. No such luck for the late Mr. Giles. His services were held at the Third Baptist Church and Reverend E.J. Croodup did not sugarcoat Giles's demise. In the presence of a large congregation, which included the lawful widow, the preacher denounced Giles as a "backslider who professed to be a good churchgoer, [who] turned out to be a notorious liar, and he was hurled into eternity with a lie on his lips." He added that despite Giles's claim to be a church member, he never attended services or allowed his children to come to Sunday school. Croodup told his listeners that they should take a cue from Giles's demise and live upright lives: "As we sow our seeds we must expect to reap them."

But even Reverend Croodup's anti-eulogy was tarts and gingerbread compared to the words stated by a minister at the funeral of a woman named Tish who died at Cynthiana, Harrison County, in April 1900. The sermon began with the words: "My subject is 'Tish is dead.' My text, 'Let her alone.'"

The Empty House

When Elvis Presley's mother died, he had her room at Graceland sealed off as a shrine to her. But John Downard, the postmaster of West Point, Hardin County, did the King one better. When his mother died in April 1902, he left her completely furnished cottage unoccupied and exactly as she left it. The small house had been built in 1856 and while Downard took care of the flowers and fruit trees in the yard, he seldom entered the house. A reporter wrote in 1903, "After her funeral, the doors of the cottage were closed and for more than a year no one, save members of Mr. Downard's family, has crossed the threshold, and even the family will not disturb its contents…[Mr. Downard intends] to keep the old home of his parents as a memory, undisturbed, as long as he lives or until time shall crumble it away."

A Father's Vigil

Elderly Benjamin Ball and his sixteen-year-old daughter lived on the Dix River in Mercer County. The girl was in perfect health until March 2, 1903, when she was afflicted with an unaccountable illness. She began sneezing constantly; the longest period of time between sneezes was one minute. After a month this torment ended, but three weeks after it ceased it began again. Her body wasted away. A contemporary describes other unpleasant symptoms: "Her arms and legs doubled up and it was impossible to straighten them, and during the last few days of her illness her pain was so great that it took several strong men to hold her in bed. She made repeated efforts to bite herself and would try to pull the hair from her head." Physicians traveled from near and far to see Miss Ball and diagnose her case. All left puzzled and helpless. At last, she literally sneezed herself to a merciful death.

The horror did not end there. The heartbroken Mr. Ball became convinced that the doctors who had been useless to his daughter while she was alive would dig up her body in order to dissect and

examine it. For months, he kept a nighttime vigil at her grave, fully prepared to give intruding medicos some double-barreled discouragement.

A Distasteful Dream

On the night of Sunday, March 2, 1856, Mr. Harrison Stratton of Clay Village, Shelby County, had a dream in which he saw "the most beautiful babe he ever saw in his life" lying dead under the kitchen floor of a villager named Sloan. In the dream, Stratton was surrounded by grotesque-looking people "of every color and shape, some [with] heads as large as bushels." He had the same dream the next night. On the third night, he dreamed that he saw people removing the child's corpse from under the floor and placing it under the corner of Sloan and Neal's store.

As everyone knows, if you dream something three nights in a row it must be true. Stratton needed no further convincing. He went to Sloan's store and looked under the corner. (Apparently the building was slightly elevated on stilts.) He thought he saw something wrapped in a blanket with an arm protruding. Before proceeding farther, Stratton found a man named Guthrie to serve as a witness and soon a small crowd of men had retrieved the blanket. Inside they found a dead female baby with thick black hair, just as Stratton claimed to have seen in his dreams. The above information was entered as legal evidence in court.

The coroner determined that the child had died by violence around two months before, as "its face and head [were] much bruised and mangled." Stratton said that the mother's identity had been revealed in his dreams, but he refused to divulge it. The jury's verdict: "That it was a female white child, born at maturity alive, and murdered by unknown hands."

Making Good a Premature Obituary

The editor of the *Owenton [Owen County] News* considered Lee Morgan a major pest. Morgan, a resident of Cleveland (now Perry Park) and a well-known businessman, was considered eccentric to the point of being borderline insane. He suffered from a burning desire to read his own obituary and repeatedly asked the editor of the *News* to run his death notice, even offering to pay for the privilege. After about eight years' worth of being cajoled by Morgan, the editor finally gave in and published a mock obituary in September 1898, along with a notice informing readers that the subject was not actually dead. Satisfied, Morgan committed suicide a few days later by overdosing on morphine.

In the Good Old Days Before Miracle Drugs

Our ancestors were regularly scourged by smallpox, a febrile disease spread by a virus. For the unlucky, smallpox was fatal; for the lucky, it merely left one disfigured by deep facial scars and pits. It was also highly contagious. The only good thing about it was that if you got it and survived, you were immune, as with measles or the mumps. Smallpox was long ago eradicated by vaccination programs. For most people, it is now just a quaint old-timey disease referred to in antiquated books; those who have no personal recollection of smallpox mistake it for milder illnesses like chicken pox.

The level of terror smallpox truly aroused in our forebears might be gauged by an event that took place in Moseleyville, Daviess County, in March 1899. When a sawmill worker named Wells was discovered to be ill with smallpox, his petrified coworkers built a shack for him on the property of a farmer named Charles Stiles, filled it with provisions—and then they nailed up the entrance, leaving Wells to his fate. A press report concluded, "Efforts are being made to secure an immune nurse to go to his assistance, if alive, or bury him if dead."

A physician, Dr. H.C. Duvall of Millwood, Grayson County, recalled an experience that illustrates the fearful hardiness of the smallpox germ. In 1872, he made a house call to see a smallpox-stricken child at the residence of the Fraise family of Leitchfield. No one could figure out how the child caught the disease, since the Fraises lived in isolation and had not been exposed to it. "Finally the mother of the child said that her father had died with the smallpox more than fifty years ago, and that she had the week before gotten a sponge out of a trunk that had been used in her father's illness and had bathed the child's eyes with it." Dr. Duvall theorized that the germ had lain dormant in the sponge for five decades, but became active when exposed to warm water and placed in the child's eyes. The child later died of the disease, as did both of its parents.

A Coffin Made to Order

Joe Biggs of Jonathan Creek, Marshall County, had often expressed a wish during his final illness that when he died, his coffin be made from a walnut tree in his yard that he had planted as a young man. When he died at age eighty-nine on July 22, 1899, his neighbors went to extraordinary lengths to oblige his final wish. They cut down the tree on the night of his death and hauled it to a sawmill the next morning. The owner agreed to cut the tree into lumber. A carpenter then assembled the pieces into a coffin, in which Biggs was buried on July 24.

Timely Deaths

November 1899 found Frank Miller of Wolfe County on his deathbed. His brother John, who was in fine health, offered a melodramatic prayer on his brother's behalf. "Oh Lord," John Miller cried as he knelt, "I am willing to give my life if it be required to save my

brother." Then John rose to his feet and died on the spot. The prayer did not help Frank, however. He obeyed the pale angel the same night and both brothers were buried in a single grave.

One day in March 1900, Sidney Murrah, former deputy sheriff of Adair County, visited his brother James in Taylor County. Mr. Murrah was telling those assembled about the demise of a former acquaintance who had passed away without warning just as he started to cut rails with an axe and maul. Mr. Murrah fell dead out of his chair in the middle of his anecdote, right after saying the words, "He fell dead."

The Chandler Normal School's commencement exercises took place on the stage of the opera house in Lexington, Fayette County, on the night of May 23, 1901. As a student named George Grimes sang a song called "India, Revelry of Death," his father Andrew died of heart disease while sitting in the audience.

Postmortem Pandemonium

Premature burial used to be so common that our ancestors became obsessed with making sure that it never happened to them. When Thomas Hall, a wealthy farmer of Lamont, McCracken County, died at age seventy-three on April 17, 1901, his sons fulfilled his instructions: an air shaft led from his casket to the earth's surface so he could breathe fresh oxygen in case he revived. (How this device could have prevented the odor of decomposition from wafting to the surface is not explained.) In addition, Hall was buried with a string wrapped around his hand, the other end of which led to a flag atop his grave. Should he be entombed alive, he could pull the string, thus lowering the flag and alerting surface dwellers that he was in peril—shades of Poe's story "The Premature Burial." Hall's phobia was such that a watchman was hired to keep an eye on the grave.

But as the poet Burns wrote, "The best laid plans of mice and men, etc." The watchman headed for shelter during a thunderstorm on the night of April 20. When he came back, the

flag was down! He notified the family and in the morning the Halls and several hundred neighbors were in the cemetery, excavating the casket of Mr. Hall. When they opened the lid he appeared to be really and truly deceased. A doctor's examination confirmed it. The Halls reburied the body and removed the ingenious air shaft. It was supposed that strong winds had blown down the flag during the storm.

Another Argument Against Suicide

B.B. Widmer, a gold and copper miner who had struck it rich in Idaho, came to Owensboro, Daviess County, in July 1901 to present his sister Pauline and her daughter with $10,000 in gold certificates. He found to his chagrin that they had quaffed carbolic acid on June 30, 1897, due to despondency caused by their poverty. Said a news account, "Upon being told that his people had committed suicide and on account of poverty, he began to swear furiously at himself for having neglected them."

THE GHOST OF THE MOTHER OF
A DRUGGIST

In 1880, Robert C. and Margaret Stockton built a spacious, two-and-a-half-story Victorian frame house on a residential street in the heart of Richmond, Madison County. The family trade was pharmacy and over the decades several Stocktons became prominent druggists.

A number of people died in the house over the years, as is true of all old residences. One untimely death was that of Matthew Stockton, son of Edward Dorsey and Mary Catherine Stockton. (I am not sure what relation they were to the original builders.) From the mid-1880s, Matthew worked as a furniture salesman, an undertaker and a druggist. He died at age forty on April 21, 1891, after an illness of several years' duration. The house is now haunted, but the ghost is not that of Matthew, despite his premature demise.

One of the last family members to own the house was Edward Claiborne Stockton, son of Robert and Margaret, the original builders. Unable to face the damage done to his business by the Great Depression, he used his pharmacist's knowledge to end his life on October 21, 1937. He drank phenolic acid in his store, walked home and died in the house. The local paper politely said he had died of a heart attack, but his death certificate proves otherwise. His funeral was held in his house two days later. Edward's tragic self-destruction would seem to make him a promising candidate for ghosthood, but he also is not the haunter.

The Ghost of the Mother of a Druggist

The house was occupied by various families until 1977, when the house was sold to the Karambellas family, the head of which was—can you guess his occupation?—yes, another druggist. They moved out around 1981 and the residence was empty for a couple of years. In June 1983, a professional couple, Mr. and Mrs. Jones, moved into the Stockton house. By some cosmic coincidence, Mrs. Jones was also a pharmacist. Mr. Jones was an attorney and certainly not a believer in ghosts.

After a few uneventful days in the house, the Joneses realized that they might have an unasked-for roommate who had been dead for nearly a century. The first incident occurred at the attention-getting hour of 2:00 a.m. on June 18, 1983: a picture in the dining room came loose from its nail and fell to the floor. Not particularly mysterious in itself but next, the Joneses had problems with a lamp in the entrance hall that kept switching itself on and off. Fearing that it might have bad wiring, they replaced it with a new lamp, but it also behaved as though it had a mind of its own.

Events took a major escalation on the night of July 19. Mr. Jones, generally a sound sleeper, snapped awake in the middle of the night and saw an uncanny figure standing at the foot of the bed. It was an elderly woman with long blonde hair and a milk-white countenance with sunken brown eyes and blue eyelids. Her face was homely and deeply lined. She wore a white layered dress. (When Mr. Jones later saw the librarian's ghost in the 1984 film *Ghostbusters*, it immediately reminded him of the phantom he saw in his own house.)

Many years after the incident, Mr. Jones related that the woman's deep, hoarse, mannish voice was one of her most frightening features. Most of what she said was indistinct, but she muttered something about looking for a picture and going to a funeral. Jones had the presence of mind to glance around the room to see if either his wife or his cocker spaniel was aware of the ghost. Both were asleep. Jones noticed that the time was 2:20 a.m. When he looked back at the foot of the bed, the figure was gone.

Any hopes he had that it had been only a dream were dashed the next morning. Fifteen baskets the Joneses had hung in their kitchen had been taken down and scattered across the floor. Three days after

he saw the ghost, Mr. Jones decided to tell his wife about the strange visitor. She didn't believe him.

Unexpected confirmation of his experience came on October 30 as Mr. Jones cleaned out a crawlspace in the third-floor attic. He found many interesting relics of the past owners, including old letters and papers and an oil painting of fruit, dated February 1891. Suddenly, he found himself face to face with the being he had seen in the bedroom doorway three months before. Jones's heart skipped a few beats until he realized he was looking at a long-discarded oil painting.

When he brought the painting into the light, Jones saw that it was dated January 27, 1891, and the subject resembled perfectly the mysterious old woman he had seen, right down to the heavy jowls, round staring eyes, downturned mouth and sour expression. She was depicted wearing "widow's weeds," complete with a black cap, which indicated that the portrait had been made while she was in mourning. Having seen the portrait myself, I can only compare the likeness to the late character actress Anne Ramsey, who appeared in the film *Throw Momma from the Train*.

Perhaps this was the painting the ghostly loiterer had mentioned seeking. After the Joneses framed the portrait and hung it in the dining room, they received unspoken signals that the spirit was pleased. The Joneses researched the history of the house and decided that the ghost's identity was Mary Catherine Stockton, wife of Edward Dorsey Stockton and mother of Matthew, who had died so young in the house. She had died on July 16, 1898, at age sixty-nine, "after a protracted illness of several weeks," according to her obituary. In life, she had had rather a domineering personality—which the ghost also had, in spades—and, I mention as an interesting tidbit of local history, she allegedly had been one of the first women in Richmond to own an automobile.

Mr. Jones took the painting to a Lexington psychic, who told him that the woman in the portrait was definitely his ghost. The clairvoyant had the impression that she had dominated men all her life and would try to do the same to Mr. Jones. The way to handle her, said the psychic, was for Jones to talk back to her and show her that he would not put up with any nonsense. The ghost

had taken a shine to him because she mistakenly believed he was her son Matthew. The psychic revealed that Mary Stockton's ghost was able to go anywhere in the house that she pleased, even outside to the patio, but that she favored the attic and the front parlor. She was most active at Christmastime, her favorite holiday, and would be seen most often around 2:00 a.m. The psychic added, "You will see her again in the huge gold mirror in the hallway. You will look in the mirror and see her reflection some morning around 2:00 a.m."

For months, Mr. Jones made it a habit *not* to look at the mirror, but around 2:00 a.m. on the night of February 1, 1984, he went to turn off a hall light. While doing so, he accidentally glanced at the mirror—and saw Mary Stockton reflected in it. She was sitting on an antique sofa in the front parlor. Mr. Jones quickly left. When he returned to check the front parlor she was gone, but he felt a warm spot on the couch, as though someone had been sitting there.

The Stockton house was located next door to a Tau Kappa Epsilon fraternity house. Some of the members confided to the new owners that they had seen lights going on and off in the Stockton house at night during the two years it had stood empty.

Mr. and Mrs. Jones were careful to restore the house to its former beauty and decorate it with antiques; they got the impression that Mrs. Stockton appreciated the gesture. Gradually, they came to view their ghost as being likeable—though unnerving and a trifle bossy. Eventually, Mr. Jones developed enough of a bond with Mrs. Stockton's ghost that he could sense when she was present in the house. The door to the third floor often unlatched itself and the Joneses could hear footsteps in the attic.

In October 1984, Mr. Jones saw a shadowy form in the dining room mirror, after which a light in the parlor turned itself off. During the 1980s and '90s, the Joneses kept a television on top of a refrigerator; like the lamp, the TV would turn itself off and on repeatedly. He had it checked out and the repairman found nothing wrong with it.

Mrs. Jones's father lived in the den for six years before his death in 1989. Often he would remark cryptically, "There's a haint in this

house." He would provide no details when pressed and his manner seemed to indicate that he considered the matter closed.

Once the Joneses had friends over. While sitting at the kitchen table, every person in the group saw the drawers of a sideboard opening and closing of their own volition. "Who's doing that?" the guests asked. "Mrs. Stockton," Mr. Jones replied. Perhaps she was simply in a mood to show off that night, for on another occasion Mr. Jones refused to show the third floor to company during a party because he instinctively felt that she was up there and did not want to be disturbed.

One day, a family friend came to visit and in the middle of conversation with Mr. Jones the woman's face blanched. "You just saw her, didn't you?" asked Jones. The shaken guest confirmed that she had seen a woman standing in a doorway with her back to her. The ghost wore a long black dress with a bustle and puffy sleeves and she had blonde hair done up in a black net. Mr. Jones found the detail of the black dress particularly interesting, since earlier the same day he had seen the ghost of Mary Stockton standing in front of a Christmas tree and wearing the very same dress described by the visitor. In all her previous appearances, the ghost had worn white.

(The visitor, by the way, should have felt proud of the fact that she was the only female ever to see the ghost, who appeared exclusively before males. Mrs. Jones never saw the ghost or even felt its presence in all the years they lived in the house and admits that she would have been skeptical of her husband's story if not for the fact that he had described the ghost to her before he found the painting.)

On Memorial Day 1985, Mr. Jones went to the Stockton family plot in Richmond Cemetery in order to pay his respects. He noticed that Matthew Stockton's tombstone had toppled over. The front hall lamp that had so bedeviled the family had not turned itself on and off for two years, but the very next morning it started its familiar tricks again. Mr. Jones took the hint and said aloud, "All right, Mrs. Stockton, I'm going to call the cemetery and have them put Matthew's tombstone back up." He kept his word and the lamp behaved.

The Ghost of the Mother of a Druggist

In October 1985, the *Lexington Herald-Leader* ran a feature on Richmond's haunted house. The day after, Mr. Jones received a phone call from a man in Mount Sterling who had lived in the house with an aunt and uncle while he was attending Eastern Kentucky University in the 1970s. The caller described supernatural experiences that were very similar to Mr. Jones's own; he was able to provide a perfect description of the ghost, although the *Herald-Leader* article did not describe it in any detail.

The Lexington psychic to whom Mr. Jones had taken the painting had further interesting news: she announced that someday the Joneses would have a son and that the baby's presence in the house would make Mrs. Stockton very happy. They scarcely believed the psychic's words, for they had been unable to conceive a child after several years of marriage. In 1993, however, they had a son. They never told him about the woman upstairs so as not to frighten him, but he sensed her presence anyway. When he became a toddler he talked about the "witch" who lived at the top of the stairs and feared that she would break his toys. To this day, he vividly recalls seeing the ghost when he was three years old. He claims that she stood at the top of the attic stairs and wore a white gown and a black hat with a white stripe around it. She said nothing to the boy in that frightening voice, thank goodness, but she stood with her arms outstretched like Christ on the cross. Perhaps it was intended as a friendly "come to me" gesture.

While the family lived in the Stockton house, Mr. Jones saw the ghost an average of once or twice a year. The last sighting was in 1998. She spoke to him only twice. The first time was on the night she appeared in his bedroom; on the other occasion, she said something about a fan in her guttural, barely intelligible manner. On a whim, Mr. Jones went to the Turpin Funeral Home and got a hand-held cardboard fan of the sort that mourners cooled themselves with in the days before air conditioning. He left it on top of some Madison County history books on a desk. The fan got into the habit of disappearing and turning up in unexpected places.

After eighteen adventurous years of living with their shadowy roommate, the Joneses moved out of the house. They left not

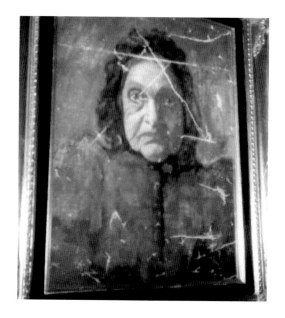

on Mrs. Stockton's account, but because a newly constructed apartment complex next door ruined the historical integrity of the neighborhood. They made certain to give the house's buyer full disclosure about the ghost. The Joneses left the portrait of Mrs. Stockton behind in the dining room, but the new owner took it down. Not long afterward, he lost his job and his mother died the first night she came to visit. But that was probably all a coincidence.

THE LAST WORD:
A COLLECTION
OF KENTUCKY EPITAPHS

On Mary Randolph Marshall (1737–1807), the mother of Chief Justice John Marshall, near Washington, Mason County:

She was good but not brilliant,
Useful but not great.

Reportedly in Kingston, Madison County:

Winfield Moody
Born 1820
Died in Madison County, Hell Knows When.

In Long Creek Cemetery, Trigg County:

Perfect grandparents of 16 imperfect grandchildren.

In Mount Kenton Cemetery, Paducah, McCracken County:

Born to Die August 14, 1840.
Died to Live May 30, 1878.

Epitaphs on gravestones side by side in Maplelawn Cemetery, Paducah:

(Wife)
Do not stand
At my grave and cry.
I am not here; I did not die.

(Husband)
If we did not die,
What are we doing here?

In Richmond Cemetery, Madison County:
> *Nothing matters. What if it did?*

An old epitaph in Richmond Cemetery that since has taken on an unfortunate new meaning:
> *In memory of our children who sleep around.*

In Riverside Cemetery, Hazard, Perry County:
> *Snug as a Bug in a Rug.*

Major Jacob Crosthwait of Connersville, Boone County, was a firm believer in moving the national currency from the gold standard to the silver standard, a subject of fierce debate during the 1890s. When he died in January 1895, he requested that his epitaph preserve his political beliefs:
> *Free Silver, at the Ratio of 16 to 1.*

Another Kentuckian who took politics to the grave was Cora Bales Sevier (1884–1961), who was buried in Barbourville Cemetery, Knox County. Her epitaph lists the roles she played in her life (artist, swimmer, fashion businesswoman, author), but it begins with what she evidently considered her crowning achievement:
> *She never voted the Republican ticket.*

When a paper called the *Roundabout* described the following Frankfort epitaph in July 1899, the editors left out the subject's name and precise birth and death years, possibly out of fear of a lawsuit:
> *Born July —, 184—*
> *Died September —, 187—.*
> *May He Rest In Peace*
> *From His Wife.*

Reportedly in Western Cemetery, Louisville, Jefferson County:
> *Sacred to the memory of W. White, who died June 26, 1836,*
> *aged 35. Caused*

by the sting of a bee over the right eye, and did not survive twenty minutes.

Two gravestones side by side in London Cemetery, Laurel County:

Molly R.
Wife of E.H. Johnson
1878–1917
No Better Woman
Ever Lived.

Sarah E.
Wife of E.H. Johnson
1874–1906
No Better Woman Ever Lived.

On L.D. Young (1842–1926), in Carlisle, Nicholas County:

His life was a failure. He died without money.

A cemetery in Henderson, Henderson County, was reported in 1887 to have a gravestone that read:

As you are now, so once was I;
As I am now, so you shall be;
Prepare for death and follow me.

A wise guy added the following lines in pencil:

To follow you I'm not content
Unless I know which way you went.

In Lancaster Cemetery, Garrard County:

Allan A. Burton
Born February 14, 1820
Died July 13, 1878
I know not whence I came, nor whither I go. I only know that I am.

In Willow Springs Cemetery, Liberty, Casey County:

Do you hear me?

On Henry Atkinson, Green Lawn Cemetery, Franklin, Simpson County:

H.C. Atkinson will occupy space in this lot just as soon as his present contract with nature has been completed. Please keep off the grass.

BIBLIOGRAPHY

The Ghosts of White Hall

Bucher, Maryleigh. "Ghostly Occurrences Common at White Hall State Shrine." *Richmond Register*, October 27, 1984, 1.

McQueen, Keven. *Cassius M. Clay, Freedom's Champion*. Paducah, KY: Turner, 2001.

Mullins, Charles. E-mail to author, June 14, 2006.

Mullins, Lashé. E-mail to author, June 2, 2006.

Sawyers, Joy. Personal interview, August 17, 2006.

Siegel, Carolyn. "Is White Hall Haunted? Maybe So." *Richmond Register*, October 25, 1989, 12.

Steele, Michelle. E-mail to author, November 9, 2005.

Temple, Mia. E-mail to author, July 15, 2006.

Warren, Jim. "Trio Take In Ghostly Air of White Hall." *Lexington Herald-Leader*, October 30, 1984, D1+.

The Reaper Gets Creative

No Diagram Necessary

Clift, G. Glenn. *Kentucky Marriages 1797–1865*. Baltimore: Genealogical Publishing Co., Inc., 1978.

BIBLIOGRAPHY

SURGEONS AT TEN PACES

Collins, Lewis. *History of Kentucky*. Frankfort: Kentucky Historical Society, 1966. (Reprint of 1874 edition.)

THE MAN WHO DIED IN A CLOCK

Wilson, J.S. "Tragic History of an Old Clock." *Louisville Courier-Journal*, October 17, 1897. Section II, 5.

A NEW USE FOR WOOL

"Kentucky News." *Louisville Courier-Journal*, December 5, 1877, 2.

HOMESPUN HARA-KIRI

"So Runs the World Away." *Louisville Courier-Journal*, August 8, 1879, 1.
"That Singular Suicide." *Louisville Courier-Journal*, August 9, 1879, 3.

WHY CATS ARE SOMETIMES BEST LEFT OUTSIDE

"Hideous." *Kentucky Gazette* [Lexington], February 9, 1881, 2.
"Most Horrible." *Louisville Courier-Journal*, February 6, 1881, 3.

DEATH IN AN OUTHOUSE

"A Dreadful Death." *Louisville Courier-Journal*, July 19, 1882, 2.
"Two Sudden Deaths." *Louisville Commercial*, July 19, 1882, 4.

DETERMINATION IS A VIRTUE

"For the Second Time." *Louisville Courier-Journal*, July 19, 1885, 9.
"A Ghastly Suicide." *Louisville Courier-Journal*, July 18, 1885, 6.
"Tom Hanlon Dead." *Louisville Courier-Journal*, July 26, 1885, 8.
"Tom Hanlon Getting Well." *Louisville Courier-Journal*, July 23, 1885, 8.

HIDDEN IN A HORSE

"Ghastly Discovery in Green County." *Louisville Courier-Journal*, February 9, 1887, 5.

"A Man's Body in the Carcass of a Horse." *National Police Gazette*, February 26, 1887, 3, 5.

THE MAN WHO TRIED TO FIGHT A TRAIN

"Defied the Engine." *Louisville Courier-Journal*, November 19, 1887, 8.

A SLIGHTLY FOOLISH WAGER

"Death at the Corner." *Louisville Courier-Journal*, January 21, 1889, 5.

"Death Won the Wager." *Louisville Courier-Journal*, January 14, 1889, 3.

"Envious Outsiders." *Louisville Courier-Journal*, May 5, 1889, 12.

"A Horrible Death." *Louisville Courier-Journal*, April 18, 1889, 4.

SCARED TO DEATH

"Killed by a Spook." *Louisville Courier-Journal*, September 4, 1889, 2.

MISSION ACCOMPLISHED

"Bled to Death." *Louisville Courier-Journal*, November 4, 1893, 1.

"THE MOST PECULIAR DISEASE"

"In and About Kentucky." *Louisville Courier-Journal*, February 6, 1894, 4.

KENTUCKY CRUCIFIXIONS

"Too Horrible For Truth." *Louisville Courier-Journal*, July 7, 1895, 2.

"Woman Nailed to a Tree." *Louisville Courier-Journal*, August 22, 1894, 2.

TONGUE TWISTER

"Pulled Out His Tongue." *Louisville Courier-Journal*, November 9, 1894, 6.

LISTEN TO YOUR INSTINCTS

"Whirled to Death." *Louisville Courier-Journal*, April 5, 1895, 8.

CHAMBER (POT) OF HORRORS

"Wired from Kentucky Towns." *Louisville Courier-Journal*, October 26, 1897, 3.

A REMARKABLE DISPLAY OF STAMINA

"Murdered a Woman." *Louisville Courier-Journal* December 26, 1898, 8.

YOU FIRST!

"Deadly Drug." *Louisville Courier-Journal*, January 19, 1899, 5.

AXE-IDENT

"Companion's Ax Glanced." *Louisville Courier-Journal*, March 2, 1899, 1.

BRIDGE TO THE OTHER WORLD

"To His Death." *Louisville Courier-Journal*, August 7, 1899, 5.

A SUCCINCT OBITUARY

"Blew Into the Muzzle." *Louisville Courier-Journal*, October 22, 1899. Section II, 1.

SHOTGUN SANTA

"Kills Wife." *Louisville Courier-Journal*, December 25, 1899, 1.

His Last Practical Joke

"To Frighten a Child." *Louisville Courier-Journal*, November 22, 1900, 4.

A Comprehensive Demise

"A Hunter's Terrible Death." *Louisville Courier-Journal*, March 18, 1901, 1.

Take Pride in Your Work

"Hanged Himself in a Tree Top." *Louisville Times*, June 29, 1901, 1.
"Hangs in Midair." *Louisville Courier-Journal*, June 30, 1901. Section I, 2.

The Fruits of Impatience

"Bullet for Pigeon…" *Louisville Courier-Journal*, July 24, 1901, 8.

That Did It

"Farmer Blows Head Off With Dynamite." *Louisville Courier-Journal*, August 27, 1901. Section VI, 1.

Rather a Bad Idea

"Negro Blown to Pieces." *Louisville Courier-Journal*, March 19, 1902, 3.

Life Imitates a Wile E. Coyote Cartoon, Part One

"The Victim of a Peculiar Accident." *Louisville Courier-Journal*, June 3, 1902, 6.

Safety Tip: Always Check Your Pistol Before Aiming It at Your Head

"Was Not Afraid to Snap the Pistol." *Louisville Courier-Journal*, June 6, 1902, 5.

HOISTED BY HIS OWN PETARD

"First to Die in Trap He Set for a Thief." *Louisville Courier-Journal*, May 3, 1904, 2.

KILLED BY THE POWER OF SUGGESTION

"Imagination Caused Death, Say Physicians." *Louisville Courier-Journal*, June 2, 1905, 1.

THE FATAL TOY CANNON

"Killed By Toy Cannon." *Louisville Courier-Journal*, December 26, 1905, 1.

LIFE IMITATES A WILE E. COYOTE CARTOON, PART TWO

"Picks up Dynamite." *Louisville Courier-Journal*, December 1, 1906, 1

AN UNSEEMLY PRANK

"Leaps to Death." *Louisville Courier-Journal*, October 17, 1907, 3.

THE REAPER GETS FRUSTRATED

"He Has More Lives Than a Cat." *Louisville Times*, June 17, 1901, 2.
"James Billiter." *Williamstown Courier*, May 30, 1901, 19.

They Predicted Their Own Deaths

"At Rest." *Louisville Courier-Journal*, September 15, 1887, 1.
Bailey, Jack Dalton. *Murders, Mischief, Mysteries, Mayhem, Madness, Misdemeanors and Downright Meanness in Mercer, Vol. Three*. Harrodsburg, KY: n.p., 2005.
"Came True." *Louisville Courier-Journal*, March 26, 1903, 2.
"Elizabethtown." *Louisville Courier-Journal*, March 23, 1880, 4.
"Fateful Premonition." *Louisville Courier-Journal*, February 11, 1900. Section I, 7.
"Had Visions of Death and Arranged Funeral." *Louisville Courier-Journal*, June 29, 1905, 4.

"His Wish Was Realized." *Louisville Courier-Journal*, March 22, 1892, 2.

"In and About Kentucky." *Louisville Courier-Journal*, January 2, 1897, 6.

"Kentucky Talked About." *Louisville Commercial*, September 22, 1887, 2.

"Made Burial Clothes While in Good Health." *Louisville Courier-Journal*, January 14, 1903, 3.

"Matters in Kentucky." *Louisville Courier-Journal*, August 8, 1898, 4.

"Predicted His Own Death." *Louisville Courier-Journal* 29 Aug. 1895: 1.

"Predicted the Date of Her Death." *Louisville Courier-Journal*, October 17, 1896. Section II, 1.

"Prediction Came True." *Louisville Courier-Journal*, January 7, 1900. Section I, 6.

"Predicts Death." *Louisville Courier-Journal*, May 10, 1906, 5.

"Staked His Life." *Louisville Courier-Journal*, May 3, 1897, 1.

Some Bluegrass Ghosts

THE HAUNTED BEE GUM AND THE BOISTEROUS COFFIN

"Ghostly Rapping." *Louisville Courier-Journal*, August 14, 1897, 4.

Horn, Tammy. *Bees in America*. Lexington: University Press of Kentucky, 2005.

"A Knocking Gum." *Richmond Climax*, August 10, 1887, 3.

A GHOST COMES TO CHURCH, MAYBE

"A Ghost in Church." *Pittsburgh [PA] Post*, October 6, 1891, 1.

THE BEAUTIFUL GHOST

"A Shadowy Wanderer." *Louisville Courier-Journal*, February 15, 1890, 2.

THE STRINGTOWN INN

"Stringtown is the Possessor of a Real Haunted House." *Louisville Courier-Journal*, January 20, 1901. Section I, 5.

THE OLD BAILEY HOUSE

"Extraordinary Case of 'Haints' in Casey County." *Louisville Courier-Journal*, May 2, 1897. Section II, 5.

THE GLIDEWELL GHOST

"The Glidewell Ghost." Editorial. *Owensboro Messenger and Examiner*, April 14, 1887, 1.
"Glidewell's Ghost." *Louisville Courier-Journal*, March 30, 1887, 4.
"Out in the State." *Louisville Courier-Journal*, April 6, 1887, 8.
"A Spirit Mystery." *Louisville Courier-Journal*, March 21, 1887, 4.
"Tam O'Shanter." *Louisville Courier-Journal*, June 13, 1887, 4.

A GHOST FROM OLD ROCKCASTLE

Wilson, J.S. "The Ball of Fire That Haunts a Grave." *Louisville Courier-Journal*, August 8, 1897. Section II, 5.

BONES UNDER THE FLOOR

"Bone Fake Played Out." *Carlisle Mercury*, June 28, 1900, 1.
"Boy Saw a Ghost." *Louisville Courier-Journal*, June 14, 1900, 6.
Colangelo, Drema. E-mail to author, January 17, 2007.

RELIABLE WRAITHS

Bailey, Jack Dalton. *Murders, Mischief, Mysteries, Mayhem, Madness, Misdemeanors and Downright Meanness in Mercer, Vol. Three*. Harrodsburg, KY: n.p., 2005.
"A Garrard County Ghost." *Louisville Courier-Journal*, June 17, 1881, 6.
"Jane Brown's Ghost." *Louisville Courier-Journal*, March 4, 1891, 5.

Embalming in the Old Days

Burns, Stanley, MD. *Sleeping Beauty*. Altadena, CA: Twelvetrees Press, 1990.
"Dead Secrets." *Louisville Courier-Journal*, August 25, 1884, 2.
"Funeral Customs." *Louisville Courier-Journal*, November 12, 1888, 5.
Lair, John. *Tales from the Hills*. Edited by Ann Lair Henderson. Mt. Vernon, KY: Polly House Publications, 1994.

"Life-Like Corpses." *Louisville Courier-Journal*, March 10, 1881, 1.
"Man's Last Expense." *Louisville Courier-Journal*, February 8, 1891, 4.
"A New Departure." *Louisville Courier-Journal*, August 10, 1895, 12.
"A Notable Operation." *Louisville Courier-Journal*, September 15, 1895. Section I, 2.
"Poisoned by Ice." *Louisville Courier-Journal*, August 8, 1885, 6.

A Ghost's Disgusting Gifts and Other Louisville Hauntings

A GHOST'S DISGUSTING GIFTS

"A Reporter Who Has 'Em." *Louisville Courier-Journal*, February 15, 1885, 8.

MR. BASLEY RETURNS

"Tenanted by Ghosts." *Louisville Courier-Journal*, January 17, 1883, 8.

THE INVISIBLE STROLLER

"The House is Haunted." *Louisville Courier-Journal*, December 12, 1886, 9.

WHY ALONZO THOMAS WENT TO WORK EARLY

"A Ghost in His Bedroom." *Louisville Courier-Journal*, May 27, 1889, 8.

THE ALFORD PLACE

"Bones of a Child." *Louisville Courier-Journal*, September 16, 1898, 4.
"Ghosts." *Louisville Courier-Journal*, January 13, 1898, 5.
"Tenanted by Specters?" *Louisville Courier-Journal*, December 13, 1891, 9.

MRS. DEWBERRY FINDS A TREASURE

"Guided by a Ghost." *Louisville Courier-Journal*, November 10, 1886, 2.
"Revealed in Dreams." *Louisville Courier-Journal*, November 11, 1886, 8.

A SHY GHOST IN BLUE

"Who Was the Mysterious Girl in a Blue Dress?" *Louisville Courier-Journal*, June 12, 1902, 4.

THE COURTHOUSE GHOST

"Ghost at Courthouse." *Louisville Times*, December 12, 1902, 1.

A Morbid Miscellany

A PREMATURE BURIAL NEARLY AVERTED AND AN INVIDIOUS MESSAGE

"A Miracle." *Elizabethtown News*, December 9, 1869, 1.

A TRAGIC TALE BRIEFLY TOLD

"The Death List in Bath County." *Louisville Courier-Journal*, October 31, 1888, 1.
"Mrs. Jane Hull…" *Carlisle Mercury*, November 8, 1888, 1.

GETTING THE FINGER

"Wanted Luck." *Louisville Courier-Journal*, September 29, 1891, 1.

YOU CAN'T KEEP A GOOD MAN DOWN

"Additional Kentucky News." *Louisville Courier-Journal*, April 17, 1872, 2.
"Alive in Her Coffin." *Windsor [MO] Review*, June 14, 1890, 1.
"Apparent Petrification." *Louisville Courier-Journal*, May 20, 1900. Section II, 6.
"As to Petrified Bodies." *Louisville Courier-Journal*, September 2, 1886, 3.
"A Bride of Death." *Louisville Courier-Journal*, July 31, 1889, 4.

"Buried Forty-Six Years." *Louisville Courier-Journal*, May 2, 1897. Section I, 3.

"Child Came to Life." *Louisville Courier-Journal*, December 16, 1900. Section I, 10.

"Culled from Kentucky Papers." *Louisville Courier-Journal*, February 15, 1899, 4.

"The Dead Lives." *Louisville Courier-Journal*, January 23, 1887, 7.

"Ghouls in Fleming County." *Louisville Courier-Journal*, September 3, 1897, 3.

"Hermit Dies on Roadside." *Louisville Courier-Journal*, October 25, 1905, 3.

"His Hair Seven Inches Longer." *Louisville Courier-Journal*, September 29, 1895. Section II, 10.

"In and About Kentucky." *Louisville Courier-Journal*, October 21, 1895, 4.

"In and About Kentucky." *Louisville Courier-Journal*, April 20, 1896, 4.

"Kentucky News." *Louisville Courier-Journal*, November 8, 1875, 2.

"Kentucky News." *Louisville Courier-Journal*, April 12, 1878, 2.

"Long Buried Dead." *Louisville Courier-Journal*, May 1, 1890, 7.

Nickell, Joe. "The Case of the Petrified Girl." *Skeptical Inquirer* (January/February 1999): 15–17.

"A Painful Scene." *Louisville Courier-Journal*, January 24, 1887, 1.

"A Petrified Woman." *Kentucky Gazette* [Lexington], October 17, 1822, 1.

"Premature Burial." Editorial. *Louisville Courier-Journal*, November 9, 1875, 2.

"Preserved Bodies." *Louisville Courier-Journal*, June 13, 1889, 5.

"Preserved Sixty Years." *Louisville Courier-Journal*, October 8, 1892, 8.

"Remarkable Preservation." *Owensboro Messenger and Examiner*, January 23, 1890, 3.

"Secrets of the Grave." *Louisville Courier-Journal*, June 24, 1888, 16.

"She Was Not Dead." *Louisville Courier-Journal*, May 28, 1889, 5.

"Somerset, Ky." *Louisville Courier-Journal*, March 9, 1881, 3.

"Vision From God." *New Orleans Daily Picayune*, February 4, 1911, 2.

"Was Buried Alive." *Louisville Courier-Journal*, July 8, 1894, 17.

"Watching the Grave." *Louisville Courier-Journal*, April 18, 1896, 2.

"Well Preserved After Sixty Years." *Louisville Courier-Journal*, August 2, 1895, 4.

"Woke Up…" *Louisville Courier-Journal*, May 5, 1903, 3.

An Unanticipated Detonation

"The Corpse Exploded." *Louisville Courier-Journal*, March 10, 1895, 13.

Crowded Quarters

"A Horrible Find." *Louisville Courier-Journal*, December 5, 1889, 2.

Resting, But Not in Peace

"Commonwealth." *Louisville Courier-Journal*, April 6, 1882, 4.
"Commonwealth." *Louisville Courier-Journal*, April 11, 1882, 5.
"Cronin's Corpse." *Louisville Courier-Journal*, April 15, 1882, 5.
"The Cronin Trouble." *Bourbon Semi-Weekly News* [Paris, KY], April 11, 1882, 1.
"Matters in Kentucky: Paris." *Louisville Courier-Journal*, April 12, 1882, 3.
"An Uneasy Bed." *Richmond Register*, April 14, 1882, 3.

A Unique Casket

"Like a Winding Sheet." *Louisville Courier-Journal*, April 15, 1882, 5.

Disgraceful Cemeteries

"The Grave's Secrets." *Louisville Courier-Journal*, April 3, 1887, 14.
"Indicted the City." *Louisville Courier-Journal*, July 21, 1897, 1.
"The Old Cemetery." *Richmond Register*, April 7, 1882, 3.
"The Old Graveyard." *Richmond Register*, May 7, 1886, 2.

Peculiar Wills

"Gets Even." *Louisville Courier-Journal*, January 8, 1902, 10.
"Rejected." *Louisville Courier-Journal*, December 17, 1897, 8.
"A Strange Will." *Louisville Courier-Journal*, July 25, 1897. Section II, 5.

He Came to Bury, Not to Praise

"Did Not Praise the Dead." *Louisville Courier-Journal*, August 22, 1897. Section IV, 1.
"A Funeral Text." *Louisville Courier-Journal*, April 21, 1900, 6.

The Empty House

"Keeps Cottage Untenanted Just as Left by Mother." *Louisville Courier-Journal*, September 7, 1903, 10.

A Father's Vigil

"Lonely Vigil." *Louisville Courier-Journal*, July 22, 1903, 4.

A Distasteful Dream

"Singular Affair—Excitement in Clay Village, etc." *Louisville Courier*, March 12, 1856, 2.

Making Good a Premature Obituary

"Matters in Kentucky." *Louisville Courier-Journal*, September 29, 1898, 4.

In the Good Old Days Before Miracle Drugs

"A Remarkable Case of Smallpox." *Louisville Courier-Journal*, August 24, 1899, 4.
"A Smallpox Patient." *Louisville Courier-Journal*, March 27, 1899, 1.

A Coffin Made to Order

"Tree Was Cut Down." *Louisville Courier-Journal*, July 26, 1899, 5.

Timely Deaths

"And He Fell Dead." *Louisville Courier-Journal*, March 21, 1900, 4.
"Coroner's Inquest." *Lexington Morning Herald*, May 25, 1901, 6.
"Died in Seat at Opera House While Awaiting His Son's Appearance." *Lexington Morning Herald*, May 24, 1901, 1.
"Father Died When Son Sang." *Louisville Courier-Journal*, May 24, 1901, 4.
"Prayed for His Brother." *Louisville Courier-Journal*, November 29, 1899, 4.
"Was Convenient to the Churchyard." *Louisville Courier-Journal*, October 25, 1902, 6.

Another Argument Against Suicide

"Idaho Mine Owner's Gift Comes Too Late." *Louisville Courier-Journal*, July 6, 1901, 1.

The Ghost of the Mother of a Druggist

Bucher, Maryleigh. "Woman's Ghost Haunts Old Richmond Home." *Richmond Register*, October 26, 1984, 1+.
Death certificate for Edward Claiborne Stockton. Number 29142. Volume 1937.
"Deaths." *Richmond Climax*, July 20, 1898, 2.
"Died." *Richmond Climax*, April 15, 1891, 3.
"Edward C. Stockton, Prominent Citizen, Dies of Heart Attack." *Richmond Register*, October 21, 1937, 1.
Jones, Mr. and Mrs. Personal interview, April 17, 2007; e-mails, August 16, 2006; August 25, 2006; March 6, 2007.
Madison County 1880 Census.
Mastin, Bettye Lee. "Richmond House Has Staying Power." *Lexington Herald-Leader*, October 26, 1985, C1+.
Rose, Lisa. "Ghost Haunts Home of University Alumni." *Eastern Progress* [Richmond, KY], October 31, 1985, 5.
"Stockton Rites Saturday Morning." *Richmond Register*, October 22, 1937, 1.

The Last Word: A Collection of Kentucky Epitaphs

Beasley, Walter. *The Bottom Line, On Tombstones, That Is*. Kuttawa, KY: McClanahan Publishing, 1999.
Burdette, Dick. "Carlisle's Epitaphs Are Resting Peacefully." *Lexington Herald-Leader*, April 15, 1996.
Davenport, Sarah. E-mail to author, October 11, 2006.

"Eccentric Maj. Crosthwait." *Louisville Courier-Journal*, January 13, 1895, 3.

"The Grave's Secrets." *Louisville Courier-Journal*, April 3, 1887, 14.

"His Contract with Nature is Completed." *Louisville Courier-Journal*, February 22, 1907, 3.

"In and About Kentucky." *Louisville Courier-Journal*, April 20, 1896, 4.

"Lancaster." *Louisville Courier-Journal*, April 11, 1903, 10.

Steele, Michelle. E-mail to author, May 3, 2006.

"Tombstone Literature." *Louisville Courier-Journal*, July 28, 1899, 4.

"Tombstones and Sentiments." *Louisville Courier-Journal*, Apr 18, 1889, 5.

Wallis, Charles L. *Stories in Stone*. New York: Oxford University Press, 1954.

Wilson, Jess D. Personal interview, circa 1985.

ABOUT THE AUTHOR

Keven McQueen is an instructor in the Department of English and Theater at Eastern Kentucky University and is the author of five books on Kentucky history, including the *Offbeat Kentuckians* series and the true crime book *Murder in Old Kentucky*. He lives in Berea and currently is working on several projects. He does not spend as much time in graveyards as you might think.

Other books by Keven McQueen:

Cassius M. Clay, Freedom's Champion
More Offbeat Kentuckians
Murder in Old Kentucky: True Crime
 Stories from the Bluegrass
The Murder of Mary Magdalene Pitts and
 Other Kentucky True Crime Stories
Offbeat Kentuckians: Legends to Lunatics

Painting by Barbara McMahan.

ALSO AVAILABLE
FROM THE HISTORY PRESS

FORGOTTEN TALES OF KENTUCKY

by Keven McQueen

978.1.59629.534.6 • 5x7 • 160 pp • $14.99